MAXFIELD PARRISH PRINTS

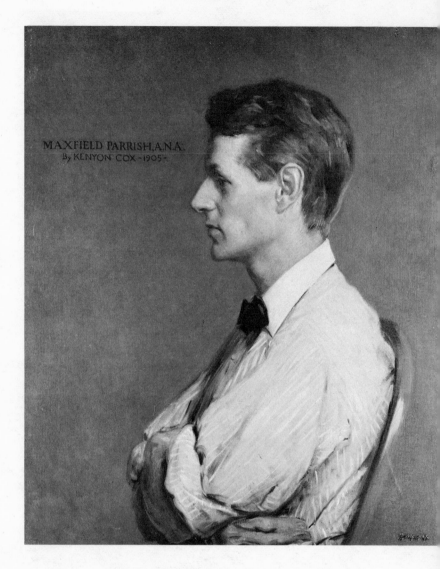

Maxfield Parrish, Portrait by Kenyon Cox, 1905

Collection National Academy of Design. Courtesy Frick Art Reference Library

Maxfield Parrish Prints

A Collectors' Guide

BY MARIAN S. SWEENEY

1974
William L. Bauhan
Dublin, New Hampshire

Library of Congress Catalog Card No. 73-81165
ISBN: 87233-029-X

Manufactured in the United States of America

TO
J. P. S.

CONTENTS

ILLUSTRATIONS

INTRODUCTION

When Maxfield Parrish died in 1966 at the age of 95, his life-time artistic output of murals, book illustrations, magazine covers, calendars, advertisements, and theatre sets placed him—according to the four-column obituary in *New York Times*—"as one of the most popular painters ever born and trained in the Country." Partly because of this popularity, as well as his willingness to apply his unique talents to commercial art of illustration, the poster, and the advertisement, the dream-like fantasy world he created has been somewhat neglected by art historians. This is as unfortunate as it is unfair. We are currently witnessing a renewed interest in, and a revival of, the art of the early decades of the twentieth century. Such revivals are a natural occurence, but with this one comes a renewed appreciation of the talents of Parrish and his contemporaries. The appearance of Marian S. Sweeney's *Maxfield Parrish Prints* is symptomatic of the interest in Parrish and, given the ever-increasing demand for his prints, is the result of the need for an authoritative guide for the collector and student.

Born on July 25, 1870, Frederick Maxfield Parrish was a product of Philadelphia, a city with strong, anti-art Quaker traditions that surprisingly served as the incubator for numerous leading American painters of the nineteenth and twentieth centuries. While Parrish's Quaker grandparents looked upon painting as a sin, his father, Stephen Parrish, was a noted etcher who exposed his son to the artistic heritage of the past through several trips to Europe. With vague thoughts of eventually becoming an architect, Parrish attended Haverford College (a Friends institution not known for its interest in the arts), but dropped out in his junior year in favor of three years of study at the Pennsylvania Academy of the Fine Arts under Thomas Eakins' successor, Thomas Anshutz. Perhaps

more influential than his classes at the Academy was Parrish's study under Howard Pyle in Chadds Ford; among Pyle's other students in the old mill along the Brandywine were such future artists and illustrators as Frank Schoonover, Violet Oakley, Jessie Willcox Smith, and N. C. Wyeth.

By 1895 Parrish had married, had done the first of his many covers for *Harper's Weekly,* and had established himself as a poster designer by winning the Pope Bicycle Manufacturing Company's poster contest. That same year Parrish also painted the mural "Old King Cole" for the Mask and Wig Club in Philadelphia, the predecessor of his more famous mural of the same name for the Hotel Knickerbocker in New York of 1906 (now in the St. Regis). Three years later Parrish moved to Plainfield, New Hampshire, close to Augustus Saint-Gaudens and other members of the artists' colony in nearby Cornish, where he was to remain until his death on March 30, 1966.

Many of his posters were designed as advertisements for such diverse products as automobile tires, light bulbs, gelatin desserts, soaps, and bicycles. But it is the magazine covers for *Harper's, Scribner's, Century, Ladies' Home Journal,* and *Life* that are most often reproduced and are among his best-known works. An example was the poster for the Midsummer Holiday Number of *The Century* of 1897, showing a pubescent wraith, knees drawn-up under the chin, and sitting before a background of lush and complicated foliage. It was so popular that Homer Saint-Gaudens recalled seeing it "glued to the wall—for better or for worse—in every properly decorated undergraduate's room at Harvard." Despite the superficial resemblance to the concurrent Art Nouveau movement suggested by the very elaborate decorative elements (such as the foliage),* Parrish's posters are typically characterized by an over-simplification and use of broad planes of color, with figures strongly silhouetted against them. Though his subjects are treated in greater detail and in a more literal manner than those of Toulouse-Lautrec, Parrish should be ranked with the greatest designers of the golden age of the poster. He understood and accepted the flatness and two-dimensionality of his surface. His

*The decoration probably owes more to Howard Pyle's love of medieval manuscripts, or to the book illustrations of American Arts and Crafts Movement artists such as Bertram Goodhue or Will Bradley, than to, say, Alphonse Mucha, one of the leading art nouveau designers.

intellectual abstraction—not to mention his use of white as color
—suggests an awareness of such media as photography and
Japanese prints, as well as a familiarity with the work of con-
temporaries such as Aubrey Beardsley, Will Bradley, and Edward
Penfield. By limiting himself to a few strong colors—colors that
are never mixed and always sharply defined—Parrish was able to
take advantage of and exploit the color processes of the printers
who would reproduce his paintings for the public.

These techniques, used so successfully on magazine covers,
were also utilized in illustrations for articles within these magazines.
His humorous, gnome-like characters in their fanciful, fairy-land
settings added a new dimension to stories such as Kenneth Gra-
hame's "Its Walls Were As of Jasper" (*Scribner's*, August 1897)
and Edith Wharton's "A Venetian Night's Entertainment" (*Scrib-
ner's*, December 1903). Poems such as Rosamond Marriott Wat-
son's "Make-Believe" (*Scribner's*, August 1912) were accompanied
by dream-like, magical scenes with romance-laden titles like "Let's
pretend the parting hour never more shall find us." Even more
evocative of that submarine hour or twilight time are paintings
for "The Waters of Venice" by Arthur Symons (*Scribner's*, April
1906), which, in a manner strongly reminiscent of James McNeill
Whistler's *Nocturnes*, show a shadowy outline of the city com-
pressed between broad zones of sky and water, composed with
monochromatic blues and grays.

Parrish's illustrations for Symons' "Venice" reflect a quiet
vision of the Mediterranean landscape which recall his earlier
illustrations for Edith Wharton's book *Italian Villas and Their
Gardens* (1903). In Mrs. Wharton's book the major components of
a scene are reduced to their simplest elements, usually dominated
by a characteristically "Maxfield Parrish blue" sky. The Wharton
book was the first in which his paintings were reproduced in color,
although Parrish began his career as a book illustrator as early
as 1897 with pictures for L. Frank Baum's *Mother Goose in Prose*.
Of the books that Parrish illustrated, from *Mother Goose* to
Louise Saunders' *The Knave of Hearts* (1925), many are children's
books, and all could be called "classics": *The Arabian Nights*
(Kate Douglas Wiggin and Nora A. Smith, 1909), Eugene Field's
Poems of Childhood (1904), Nathaniel Hawthorne's *A Wonder
Book and Tanglewood Tales* (1910), and Washington Irving's
History of New York by Diedrich Knickerbocker (1900).

These book illustrations established Parrish as the creator and
master of a dream world of fantasy and romance, and perhaps the
most successful were those for Kenneth Grahame's *Dream Days*
of 1898 and *The Golden Age* of the following year. Even his factual
scenes, such as the gardens in Edith Wharton's book, are always
rendered as "memories," but his pictures for the great English
story-teller allowed Parrish's imagination free rein (the specific
characters in Grahame's *Wind in the Willows* would have been
too constraining for Parrish) so that "it was easy . . . to trans-
port yourself in a trice to the heart of a tropical forest" where, if
not "elf-haunted," there was sure to be at least a "reluctant
dragon."

There is an undeniable romantic appeal in Parrish's work.
Because its evocative qualities are so easy to associate with (as
well as its popularity, commercial success, and almost faultless
method), it is hard for many historians to accept his work as a sub-
ject for serious study. Certainly, his art is a limited one by defini-
tion, yet Parrish had had academic training and there can be
little doubt that he studied (and selectively borrowed from) the
contemporary masters of modern art—from Whistler to Matisse,
as well as the exploratory methods and effects of photography. It
is also true that Parrish built on the "Fine Arts" to produce his
commercial art.* Parrish also consciously depicted a world without
ugliness and upheaval, often as freeze-dried as the work of the Pre-
Raphaelites, and he was often seemingly more interested in decora-
tive effect than in content. Charm may not be the quality most
sought-after in contemporary American society, and while some
may not wish to raise Parrish to the level of a major artist, he never-
theless elevated commercial art to a higher artistic plane. His un-
failing sense of architectonic construction would be praiseworthy
in any of the fine arts.

Maxfield Parrish's vision was unique, and his work holds sur-
prises for those willing to explore it. Its scope will be evident from

*This is a common-enough practice, though incidentally the reverse of Pop Art
which draws on commercial art to produce its version of "fine art." *Time Magazine*
misunderstood Parrish's position when they called him "Grand-Pop" (June 12,
1964); though Pop Art was a major contributor to the poster revival of the 1960s.
Parrish's work, despite its sentiment, cannot be classified as kitsch; its intellectuality
and its debt to modern art raise it above the true kitsch of Norman Rockwell for ex-
ample.

Mrs. Sweeney's thorough compilation of his graphic work. While this guide is intended to complement broader historical and scholarly studies, the prints alone confirm the fact that as an illustrator Maxfield Parrish has few peers, and it was an illustrator that Parrish chose to be.

WILLIAM MORGAN

Princeton, New Jersey
January 1974

PREFACE

A renewed interest has been currently growing in the romantic, fairy-tale art of Maxfield Parrish, especially among the youth of today. Serious students are re-evaluating his work, along with that of other turn-of-the-century artists.

In collecting reproductions of Parrish art I have failed to find a comprehensive catalog of his printed works, or of sources for them. Through collecting and research I have compiled a list of more than six-hundred entries: for single prints, sources in periodicals and books, and for biographical material on the artist. It is hoped that this resulting *Guide* will be of assistance both to the collector and the student.

The *Guide* is as complete as is possible at this time. I will be pleased to hear from anyone who can offer corrections or additional information.

Interest in Parrish includes a desire to see his original work, and as far as is known, most of it still exists. Many of the paintings and drawings are in private collections, but those in art galleries and public buildings may be viewed by the public. Following are listed titles and sites of some of the paintings on public view.

The Broadmoor. 1921. 27" by 34". This horizontal painting of the Broadmoor Hotel in Colorado Springs, Colorado, hangs in the mezzanine of the hotel.

The Dream Garden. 1914. 15' by 49'. A favrile glass mosaic, depicting a horizontal garden scene at the base of lofty mountains. A stream with a waterfall is on the right; another is in the left background. In the left foreground is a large tree; and in the center is a low stone wall flanked by mask designs.

This large scene decorates the lobby of the old Curtis Publishing

Company building in Philadelphia. The original design was created by Parrish for Louis Comfort Tiffany, who translated it into the mosaic.

The Florentine Fete Murals. 1912. These murals are over ten feet tall and average five feet in width. They were commissioned by the Curtis Publishing Co. for the girls' dining room on the top floor of their building in Philadelphia. Parrish created 17 murals to fill the spaces between the windows in this dining room.

Each mural is complete in itself, but is also a part of the continuing scene, which consists of costumed youths and maidens on their way to a fete. The large end mural shows young people lounging on the broad steps of the loggia of a palace, where the evening party will take place.

At this writing the dining room has been converted to office use, and the present owner of the building has boarded over the murals for safekeeping. They are included here because it is understood that they will be available for public viewing at a future date.

Interlude. 1921. 7' by 5'. This vertical scene was painted for the Rochester School of Music and hangs in the Eastman Theatre, in Rochester, New York. It portrays three girls with stringed instruments lounging beside a quiet lake. Branches from tall trees hang over them and distant mountains loom beyond the lake.

The Mask and Wig Club, of the University of Pennsylvania in Philadelphia, is the repository for several Parrish works.

In the Grille Room, which contains the bar facilities of the Club, mugs of Graduate Club members are hung about the room, with caricatures of their owners' leading roles painted beside them. A number of the first caricatures were done by Parrish.

Old King Cole (Mask & Wig). 1894. 3'9" by 11'. This is the first of two murals by this name that Parrish painted. The horizontal scene hangs in the Grille Room of the Club. The king sits in profile on the right, with a pet stork beside him. Three fiddlers face him in the center, and a chef with pipe and bowl is on the left.

The proscenium arch of the upstairs theatre has been decorated by Parrish with banners and scrolls. On each side is a robed youth in a plumed cap, holding a shield; two white storks fly toward each other at the top.

Very Little Red Riding Hood. 1897. 11¼" by 13". Little Red Riding Hood stands in a forest. She wears a bonnet with flowing

ties, a generous cape, and is carrying a basket. The original paint-
ing hangs in the Club hallway. This design was used for a pro-
gram cover for a Mask and Wig Club production in 1897. (See
Pamphlets.)

This concludes the list of Parrish works in the Mask and Wig
Club.

Old King Cole (St. Regis). 1906. 7'9" by 21'9". Parrish painted
this horizontal mural for the bar in John Jacob Astor's Knicker-
bocker Hotel in New York. In 1919, when Prohibition closed down
the bars, the mural was loaned to the Racquet and Tennis Club.
In 1935 it was installed in the St. Regis-Sheraton, Fifth Avenue
and Fifty-Fifth Street, New York, in the King Cole Bar. The mural
shows King Cole seated on his throne in the center of a long porti-
co. He wears an amused expression and is flanked by four smirk-
ing attendants. Two pages sit at his feet, "fiddlers three" prepare
to perform on the left, while the pipe and bowl are presented by
bearers on the right.

The Pied Piper. 1909. 8' by 15'. This horizontal mural was
painted for the Men's Bar in the Sheraton-Palace Hotel, New
Montgomery and Market Streets, San Francisco, where it is today.
The general public is welcome to view the mural. The Piper, in a
red suit, and a black and white checked cape, is outlined against a
spreading tree. The children scramble around him. High in the
mountains on the right is the distant town.

Sing a Song of Sixpence. 1910. 5' by 13'5". This is a horizontal
mural created for the Hotel Sherman (presently the Sherman
House) at Clark and Randolph Streets, Chicago, where it can be
seen in the Celtic Cafe. The King and Queen are seated in large
green carved chairs at a table. The pie has just been opened and
the blackbirds are singing. The King and Queen, two servants and
two pages, all wear expressions of amazement.*

At this writing original works by Maxfield Parrish can also be
seen at the Vose Galleries in Boston; the Vanderpoel Art Gallery
in Chicago; and The Pioneer Museum and Haggin Galleries in
Stockton, California, among others.

The interest and assistance of many people enabled me to create
this guide. To Velma Beisner, who encouraged the embryo idea,
who generously shared her meticulous source file and who
*This mural is reported sold (late 1973) and now in private hands.

inspired, edited and assisted all the way, I owe a great debt. I wish to thank all the collectors who gave of their time and knowledge; particularly Jutta Anderson, Arnold Benetti, Connie and Terry Frederick, Robert Henderson, Richard Mann, Jr., Gerald and Suzanne Olson, Jay Scott, Horace Taylor, Harold Knox and Michael Wood. I express a special thanks to Les and Gloria Kiddey for their encouargement, editing, and ingenious and everlasting digging for facts.

The Guide has attained its present integrity because of the cooperation of many libraries, especially the San Luis Obispo Public Library, of San Luis Obispo, California, whose staff was always ready to assist me. Patricia Clark, Margaret Price and Barbara Ryan, of that staff, have been particularly helpful.

I appreciate the indulgence of various family members and friends who have allowed me to coerce them into helping with boring but necessary details.

Alice Jo Duckworth and Pamela Gudish have edited the dross from the manuscript, leaving only the clean bones of necessity.

Elizabeth Guy receives my gratitude for her willing research, her punctilious editing, and especially for showing me what a book could and should be.

The detailed critique of the original manuscript by Grant Holcomb, professor of art history at Mount Holyoke College, resulted in significant changes and improvements.

Mr. Stephen Goff, of The Mask and Wig Club, has my deep appreciation for his generous sharing of knowledge concerning the many Parrish works at The Club.

My thanks also go to Professor William Morgan of the art department at Princeton University for his perceptive and scholarly introduction which will greatly increase the reader's understanding of Maxfield Parrish and his work.

In spite of all the professional assistance I received, the Guide could not have been completed without the love, encouragement and confidence of my family and friends.

MARIAN S. SWEENEY

San Luis Obispo, Calif.
February 1974

HOW TO USE THIS GUIDE

The following information will help to make the *Guide* a useful tool, and will assist the researcher or collector in utilizing its resources to the fullest extent.

Entries are arranged alphabetically within each section.

The notation in an entry that information has been "reported" but is "unverified" is not meant to cast doubt on the existence of the information (although some *may* be "misinformation"); rather it implies that the author has been unable to verify it personally. It is hoped that "unverified" information can and will be authenticated by users of the *Guide*, and that these authentications will be reported to the author, who will be most grateful.

Throughout the *Guide* formal titles of Parrish works appear in **bold face letters**. Works having no known formal titles will be designated in lower-case letters by reference to an associated story, poem, or by wording found beneath the print. Some of those works for which no known title or designation can be found have been arbitrarily titled by the author, and are also printed in lower-case letters, as is the case with many of *The Knave of Hearts* illustrations.

In the Index, each title or designation of a Parrish work is preceded by an asterisk.

The source for the description of any work in the Index is designated by page numbers in **bold face numerals**.

In several instances one picture bears more than one title; conversely, in some cases one title refers to more than one picture. All known titles will be listed in the body of the *Guide*, and may also be found in the Index.

A designation in parenthesis immediately following the title of a work is to facilitate identification when two or more different scenes bear the same title.

For example: With the Brown & Bigelow prints are listed two titled **Evening**. Reinthal and Newman's House of Art published a *Life Magazine* cover as a print titled **Evening**. That makes three **Evenings**. Therefore, the Brown & Bigelow prints have been designated **Evening (B & B #1)**, and **Evening (B & B # 2)**; and since the Reinthal and Newman print is a picture of a nude, its designation is **Evening** (nude). It is hoped this type of designation will simplify identification of different works bearing the same titles.

All known sizes of each print are given. Height precedes width. In the case of the Brown & Bigelow prints and the Edison-Mazda calendars, the various known sizes are given at the beginning of each section, with vertical or horizontal format given for individual prints.

The size of an illustration within a book, and the size of the same illustration as it was published as an art print, are given so that the collector may know whether he is dealing with a print which has been removed from a book, or with the larger art print.

The signature of Maxfield Parrish almost always appears on the printed reproductions of his work. It may be in any of several known forms. Many items bear a printed signature, "Maxfield Parrish." Some carry the printed initials, "M. P.," sometimes with one initial on either side of a print. On a few of his early works the initials only appear, M and the P joined, thus, **MP**. One of his first magazine covers, for *Harper's Weekly*, is signed, "F. Maxfield Parrish." In *Maxfield Parrish, A Retrospect*, published by The George Water Vincent Smith Art Museum, is listed an etching signed, "Fred Parrish." Harold Knox's *Collector's Guide to Maxfield Parrish*, pp. 28, 30, lists an early Haverford College publication bearing the three initials, "FMP."

The illustrations from *Italian Villas and Their Gardens* are not described; all of them are various aspects of villas and gardens in Italy.

All of the other works listed are described at least once, if the description is known.

Under Related Material will be found, among other things, references to Cashmere-Bouquet, Royal Baking Powder and Colgate products advertisements which some collectors believe to have been done by Parrish. A doubt remains, however, and even persons who knew the artist believe that some of these advertise-

ments may have been done in the "Parrish style" by other illus-
trators. Until positive verification can be made, they will not be
listed in the main body of the *Guide*.

Abbreviations used are as follows: n.d., no date; n.p., no page;
unk., unknown.

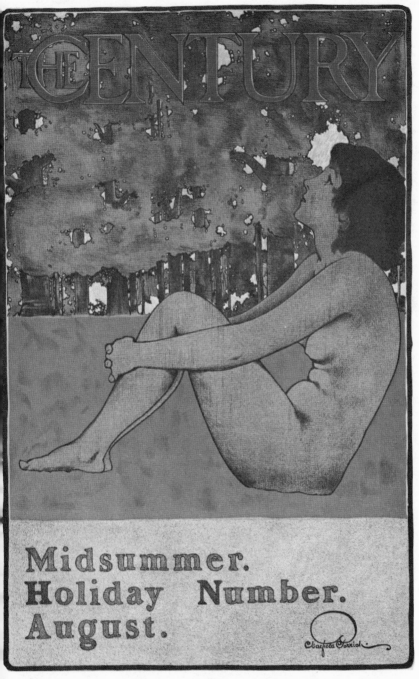

Parrish won second prize for this poster for *Century* Poster Contest in 1897. One of the most popular prints of the period.

Maxfield Parrish in later years

Photograph by Aubrey Janion. Courtesy Maxfield Parrish, Jr.

INDIVIDUAL PRINTS

Individual prints are listed under three categories; prints published by Brown & Bigelow, the Edison-Mazda calendars, and miscellaneous prints.

Individual *book* illustrations are listed under the book title in the section on Illustrations In Books.

BROWN & BIGELOW

Approximately 48 different scenes have been published by Brown & Bigelow, of St. Paul, Minnesota. Since 1936 they have been published and re-published as calendars, greeting cards and single prints, and a few of them are still being published today.

The difficulty of identifying these pictures, which were sometimes issued under two or more titles, or under titles already used for another print, is compounded by the fact that many of them are nearly alike in subject matter.

In describing the Brown & Bigelow prints an effort has been made to mention some particular aspect of each one to aid in identification. They are all in color and are known to have been published in the following sizes: 5½" by 4"; 6" by 4½"; 10¾" by 8½"; 15" by 12½"; 21¼" by 16"; and 30" by 24".

The years of publication are given.

A Christmas Morning. (See **Sunlight**.) 1958, 1967.

An Ancient Tree. 1952. Vertical. A gnarled oak tree, bearing green and brown leaves, with roots exposed at its base, is in the foreground. Behind the tree a river disappears into the distance. Mountains, and white clouds in a blue sky, are in the background.

3

This scene is currently being published as an 8″ by 12″ card, done in the foil process. Publisher unknown.

At Close of Day (#1). 1943. Vertical. In this snow scene a church with lighted windows is on the left. In the foreground, branches of a leafless tree are silhouetted against the evening sky. On either side are evergreens.

At Close of Day (#2). (See **Twilight (#2)**.) 1961, 1966.

At Close of Day (#3). 1957, 1965. Horizontal. In a winter landscape the sunset reflects from a house in the snow. A tree in partial foliage is on the left, shrubbery is in front of the house. On the right, out-buildings are in the background; a little stream flows through the foreground.

Birches in Winter. (See **Sunrise (B & B)**.) 1955, 1968.

Christmas Eve (#1). (Also titled **When Day is Done**.) 1947, 1963, 1972. Vertical. This entire snow scene is shadowed blue. In the foreground a deep blue stream has a little island of snow in it. Horizontally across the center are lighted houses and a village church. Behind the town, steep, snowy brush-covered hills rise to the top of the picture to meet a tiny patch of sky.

Christmas Eve (#2). (Also titled **A New Day**, and **When Christmas Comes**.) 1949, 1963, 1971. Horizontal. In the center of a snowy landscape is a large barn. Next to it, on the right, is a house with three lighted windows and two red brick chimneys. Behind the house are trees in green foliage. In front of the barn is a leafless tree having two main trunks, and on the right a rail fence encloses a corner of a field. The foreground snow is shadowed blue, the farther hills reflect the pink sunlight, and the sky is pale green.

Christmas Morn. (See **When Day is Dawning**.) 1954, 1968.

Christmas Morning. 1948. Horizontal. In this snowy landscape a group of white birches, with bare branches, is predominant. Beneath a pink morning sky and pale blue hills a small house nestles, with a wisp of smoke rising from the chimney. The house is fin-

ished in natural wood and green paint. Two lighted windows glow from an upstairs room.

Church at Norwich. (See **Peaceful Night.**) 1953, 1965.

Close of Day. (See **At Close of Day (#3).**) 1957, 1965.

Daybreak (B & B). (Also titled **Hunt Farm.**) 1951. Vertical. A house sits among trees at center left; a barn with a brown roof is at center right. Outbuildings overlook a small gully with a rivulet flowing from right to left. White clouds are in the summer sky, and the buildings have a rosy tint.

Early Autumn. 1939. Vertical. A quiet stream flows under a long covered bridge. On the left is a church, and on the right a white-barked tree reaches to the sky. The distant hills and the trees are richly colored with autumn foliage.

Evening (B & B #1). 1947. Vertical. In the center of the picture are a white house and barn, connected with a breezeway. In the foreground a rolling pasture is divided by a rivulet flowing from right center to left foreground. At the rear of the buildings are trees with brown leaves. The sky is blue-green.

Evening (B & B #2). 1956, 1970. Horizontal. A house with one lighted window sits on a snow-covered knoll on the left. The house and snow reflect the last of the sunset light. Large trees in green foliage are behind the house. In the right foreground is a single tall tree in full leaf, in the middle distance is flat meadow land, and in the far distance are blue mountains.

Evening Shadows (#1). 1940. Vertical. In the left foreground a many-trunked birch tree, with brown leaves, extends its branches across the top of the picture. It overlooks a valley containing a wide river and a distant village. The most striking aspect of this picture is the reflected light on the tree branches.

Evening Shadows (#2). 1953. Vertical. A house, with lighted windows and smoke rising from the chimney, overlooks a reflecting pond. Two boats are tied to a dock in the right foreground. A

large oak tree in full leaf dominates the right side of the picture. Hills reflecting the setting sun are in the left background.

Eventide. 1944. Horizontal. In the center, on a snowy knoll, is a house with two lighted windows. In the distance on the right are purple hills. A glimpse of a red barn can be seen through the trees at the rear of the house.

Freeman Farm. (See **Silent Night (#3).**) 1960, 1966.

The Glen. 1938. Vertical. This deep blue wooded scene is dominated by two large tree trunks. A quiet pool in the foregound is fed by the tumbling stream seen in the mountain background.

Golden Valley. (See **Valley of Enchantment.**) 1946.

Hilltop Farm, Winter. (See **Lights of Welcome.**) 1952, 1964, 1969.

Hunt Farm. (See **Daybreak (B & B).**) 1951.

Lights of Home. (Also titled **Silent Night (#2).**) 1945, 1964. Vertical. A house with snow-covered roof, lights in the windows and smoke rising from the chimney, sits at right center. At left center are three adjoining barns, with a leafless tree behind the farthest barn. A full yellow moon can be seen through the branches of an evergreen tree which rises from behind the house to the top of the picture.

Lights of Welcome. (Also titled **Night Before Christmas**, and **Hilltop Farm, Winter.**) 1952, 1964, 1969. Horizontal. A large bare tree trunk, which splits into two main branches, is in the left foreground. Snow-covered boulders are in the immediate foreground. Behind a snowy rise, and separated from the tree by a rail fence, are a white farmhouse and barns. Two windows are lighted in the house, and smoke rises from one of its two chimneys.

Millpond. 1948. Vertical. The barn-like mill on the right, and the large green tree above it, are reflected in the quiet pond. In the left background can be seen a distant village, with colorful hills rising to a blue sky.

It is reported that this print was used on a calendar by the Coca Cola Bottling Works, of Spirit Lake, Iowa, date unknown.

Misty Morn. 1956. Vertical. The foreground is filled with a rushing stream which flows around boulders in the lower right corner. Distant blue mountains form a background for a mass of trees in vivid autumn foliage.

Morning Light. 1957. Vertical. A great tree, with brown foliage and sunlit trunk, fills the right side and the top half of the picture. Beneath it is a stone house with steps leading from it, through a stone wall, down to a foreground stream. Slanting sunshine from a green sky lights the scene.

A New Day. (See **Christmas Eve (#2).**) 1949, 1963, 1971.

New Moon. 1958. Vertical. A large white barn with a cupola, and a tree rising behind it, sits beside a stream. A larger tree fills the upper left corner. The stream widens at center foreground, and a sliver of a new moon is in the summer sky, on the right.

Night Before Christmas. (See **Lights of Welcome.**) 1952, 1964, 1969.

The Old Glen Mill. 1954. Vertical. A golden sky is visible through the leafy branches which cover the top portion of the picture. On the left, part of the old mill, with its wheel, is visible. The quiet pond is in the foreground. Orange and blue cliffs are in the distance.

The Path to Home. 1950. Horizontal. A leafless tree on a snow-covered rise stands in the center. Footprints in the snow lead around the tree to the left and disappear toward a farmhouse in the background. Beyond the farm is a village, with mountains rising behind it.

Peace at Twilight. (Also titled **Twilight (#3).**) 1946, 1967, 1972. Horizontal. A broad stream winds through the snowy foreground. Horizontally through the picture is a village street with lighted houses. Bare trees are silhouetted against the evening sky.

This scene appears on the 1972 calendar on artist's canvas, cropped to a vertical format, titled **Twilight (#3).**

Peace of Evening. 1959. Horizontal. In this snow scene a rivulet is in the left foreground. A farmhouse, barns and outbuildings are in the center, with trees around them. A snowy tree-covered hill is in the background. The greenish sky is unusual in that it is filled with fog-like clouds.

Peaceful Country. 1963. Vertical. This scene consists mostly of trees and sky. A tall, slender tree on the right reaches from the bottom to the top of the canvas. A big oak tree is on the left, its base hidden behind mossy boulders. A small house and barns are near the bottom of the scene, with blue sky and white clouds filling out the background.

Peaceful Night. (Also titled **Church at Norwich.**) 1953, 1965. Vertical. A white church with pointed steeple, bell tower, clock and green shutters, sits in the snow. Windows on either side of the door are lighted. In the right side of the scene, a tree in full leaf reaches to the top of the picture. In the left foreground is shrubbery; and at left center, and to the rear of the church, is a house half-hidden by trees. The sky and shadows are very dark, giving the effect of moonlight.

Peaceful Valley (#1). (Also titled **Tranquility.**) 1936. Vertical. A large tree almost fills the top half of the picture. Below and beyond the tree are a lake, and a village with a steepled church. Purple-shadowed rocks lie in the foreground.

Peaceful Valley (#2). 1955. Vertical. The upper three-fourths of this scene is dominated by a single, leafy oak tree. A small, shuttered, white house on a rocky promintory is partially hidden by the tree trunk. Near the house is a barn, topped with a cupola, and with its door open. A blue sky with white clouds, and a quiet lake, are in the right side of the picture.

A Perfect Day. 1943. Vertical. A reflecting pool is in the foreground. At the right of the pool is a tall tree. Beyond the meadow is a village, with hills rising behind it. The top half of the scene consists of blue and white clouds.

Quiet Solitude. 1962. (1971, published by Arthur Kaplan Co., Inc., New York. 17″ by 14″.) Vertical. Two large trees, with boulders

at their bases, stand at the foot of a tumbling section of river. Calm water is in the foreground. The tumbling water is lighted by the sun, the quiet water is in shadow.

Road to the Valley. (Also titled **Golden Valley** and **Valley of Enchantment.**) 1946.

Sheltering Oaks. 1960. (1971, published by Arthur Kaplan Co., Inc., New York. 17″ by 14″.) Vertical. A white house in the center is almost completely surrounded by towering oak trees. The trees, and high white clouds in a blue sky, are reflected in a lake, which curves in from the left in front of the house. Shadowed boulders are in the foreground.

Silent Night (#1). 1942. Horizontal. The foreground in this winter night scene has large boulders on the right, and a tall evergreen tree on the left. At the base of snow-covered hills nestles a little town, lights gleaming from the windows of its houses. In the far distance a purple mountain looms under dark, starry skies.

Silent Night (#2). (See **Lights of Home.**) 1945, 1964.

Silent Night (#3). (Also titled **Twilight Time,** and **Freeman Farm.**) 1960, 1966. Horizontal. A large barn with two ells, green doors and a cupola, rests on a snowy knoll beneath a large tree in summer foliage. To the right and rear of the barn, a small house with two lighted windows sits among bare trees. Leafy shrubs are in the left foreground.

Sunlight. (Also titled **A Christmas Morning.**) 1958, 1967. Horizontal. In the shadowed foreground an arched stone bridge over a small stream is flanked by bare bushes. Beyond the bridge rises a snowy knoll, pink in the sunlight. At left center, on top of the hill, are a farmhouse and a barn. Leafy branches intrude at the top of the picture.

Sunlit Valley. 1950. Vertical. A colorful brook is in the foreground. A village, situated at the base of a purple mountain, can be seen through autumn foliage. The blue sky is filled with white clouds.

Sunrise (B & B). (Also titled **Birches in Winter.**) 1955, 1968. In a snowy landscape a group of gnarled birches on a foreground hilltop overlook a house, a barn, and distant hills, which are in the lower left. The snow behind the house, and the tree branches, reflect the pink sunlight.

Sun-Up. 1945. Vertical. A country home with attached barns catches the early morning light. Rain puddles in the foreground reflect the house, the great trees rising behind it, and the pink clouds.

Thy Rocks and Rills. 1944, 1972. Vertical. A high, lavender mountain rises in the background. On the right, one end of a mill and its wheel, are visible. A small village is in the center. The foreground is filled with a mountain stream flowing over boulders.

This scene appears on the 1972 calendar on artist's canvas.

Thy Templed Hills. (Also titled **New Hampshire—Land of Scenic Splendor.**) 1942. Vertical. On the left two trees with brown foliage rise into a sky filled with fleecy white clouds. A quiet lake, set among brown boulders, reflects the sky. A tiny village is shown beyond the lake, with blue mountains rising above it.

Tranquility. (See **Peaceful Valley (#1).**) 1936.

Twilight (#1). 1937. Vertical. A white house with an attached barn faces center front. A tree towers over them, occupying the upper right quarter of the canvas. The green lawn in front of the house meets a little stream in the left foreground. Beyond a purple hill in the background, the pale evening sky deepens into night.

Twilight (#2). (Also titled **At Close of Day (#2).**) 1961, 1966. (1971, published by Arthur Kaplan Co., Inc., New York. 17″ by 14″.) Vertical. A great oak tree, appearing to grow from a pile of rock, dominates this scene. A dark green mossy stream bed is in the foreground, revealing only two small glimpses of the reflecting stream. On the left, beyond the tree, houses and a church spire catch the evening sunlight. Big clouds in a blue sky fill out the background.

Twilight (#3). (See **Peace at Twilight.**) 1946, 1967, 1972.

The Twilight Hour. 1951. Horizontal. In the right center a brown barn sits on a snowy rise in front of a large, leafless tree. Half-hidden among the trees on the left is a house with two lighted windows, and with smoke rising from the chimney. The sky is yellow at the horizon, changing to gray-blue at the top of the picture.

Twilight Time. (See **Silent Night (#3).**) 1960, 1966.

Under Summer Skies. 1959. (1971, published by Arthur Kaplan Co., Inc., New York. 17″ by 14″.) Vertical. A massive tree trunk fills the right side of the picture. Branches from the tree reach across the top of the scene. The tree appears to grow out of a pile of boulders, beside a lake which perfectly reflects the clouds, and the buildings and trees on its far shore. The sky is turquoise.

Valley of Enchantment. (Also titled **Golden Valley,** and **Road to the Valley.**) 1946. Vertical. A country lane leads down the hill to a village half-hidden in trees. On the right is a large tree in autumn foliage; and below, on the left, can be seen a church spire. Beyond the town great purple mountains rise against a blue and white sky.

The Village Brook. 1941. Vertical. A stony brook runs from the lower center to the lower left corner. Immediately above it is a church, and on the right a tree fills the green sky. The entire scene appears suffused with green light.

The Village Church. 1949. Vertical. The church, with belfry and steeple, has two large columns at its entrance, and is overshadowed by a large green oak tree in front of it. At the right of the church is a smaller green tree, and a picket fence. In the right foreground can be seen a river, and on the left are small houses with lighted windows.

When Christmas Comes. (See **Christmas Eve (#2).**) 1949, 1963, 1971.

When Day is Dawning. (Also titled **Christmas Morn.**) 1954, 1968. Horizontal. In this snow scene a high, distant mountain is pale blue in the background, nearer mountains are pink, and the foreground slope is a dark, shadowed blue. Between the foreground and the pink mountains, lies a little town. A tall tree is on the left.

When Day is Done. (See **Christmas Eve (#1).**) 1947, 1963, 1972.

Winter Twilight. 1941, 1973. Horizontal. On a hillside a rail fence, half-buried in snow, crosses the foreground. On the crest of the hill, against a golden sky, are a large red barn, and a red house with two lighted windows. Leafless trees obscure the ground level outline of the buildings.

EDISON-MAZDA

The General Electric Company published seventeen prints by Maxfield Parrish between 1918 and 1934, for the Edison-Mazda Division of their company. These prints were used for calendars in a variety of sizes, as designs for playing cards, tape measures, blotters, and other promotional material. (See Miscellanea.)

The Edison-Mazda calendars are all in color, all vertical in format, and are known to have been published in the following sizes: 9″ by 6½″; 20″ by 14½″; and 23¼″ by 14½″. (These sizes apply to the illustration only, not to the calendar as a whole.)

And Night is Fled. (Also titled **Shedding Light,** and **Dawn.**) 1918. A barefoot woman is seated in right profile on a boulder, under a large tree. Mountains and a lake are beyond her. The scene is highlighted by the rising sun.

Contentment. 1928. (1973, published by Portal Publications, Sausalito, Calif. "17″ by 30″ with margins.") Two figures sit on sunlit rocks, with deep purple shadows behind them.

Dawn. (See **And Night is Fled.**) 1918.

Dreamlight. 1925. (1973, published by Portal Publications, Sausa-

lito, Calif. "17″ by 30″ with margins.") A girl sits in a swing, with her head leaning to one side in a pensive mood. Several trees, and a stream, are in the background.

Ecstasy. 1930. (1973, published by Portal Publications, Sausalito, Calif. "17″ by 30″ with margins.") A wind-blown girl stands on sloping rocks, high above a lake, with her arms flung over her head.

Egypt. 1922. (1973, published by Portal Publications, Sausalito, Calif. "17″ by 30″ with margins.") A reclining figure, a musician with a harp, and a nude child, enjoy an evening in a garden lit by a row of oil lamps.

Enchantment. (Also titled **Griselda.**) 1926. (1973, published by Portal Publications, Sausalito, Calif. "17″ by 30″ with margins.") A woman in medieval robe and girdle, poses on a flight of stairs, facing the light which shines from the right.

Golden Hours. 1929. A large tree is on the left. Two girls in a bateau pole through the waters of a woodland pond. All of the foliage is in flaming autumn color.

Griselda. (See **Enchantment.**) 1926, 1973.

The Lampseller of Bagdad. 1923. (1973, published by Portal Publications, Sausalito, Calif. "17″ by 30″ with margins.") A woman standing under an archway examines an oil lamp offered by a squatting vendor.

Moonlight. 1934. Moonlight is reflected from the boulders which fill the picture. A rushing, turquoise stream flows from the center to the lower left foreground. A girl sits on rocks at the right. (Same as **Falls by Moonlight**, with the addition of the figure. See Index.)

Primitive Man. 1921. Three figures huddle around a flaming torch.

Prometheus. 1920. (1973, published by Portal Publications, Sausalito, Calif. "17″ by 30″ with margins.") A nude youth, wearing only a helmet, carries a lighted torch to a dark world.

Reveries. 1927. Two girls sit on opposite sides of a raised pool, with bowers of roses and the branches of a tall tree, over their heads.

Shedding Light. (See **And Night is Fled.**) 1918.

Solitude. 1932. A girl sits on rocks above a lake, with a sunlit canyon beyond her, and a single pine tree rising in the background.

The Spirit of Night. 1919. A young woman in white robes is spotlighted against a dark background. Attendants stand in the shadows on either side of her.

Sunrise (Edison-Mazda). 1933. Two girls look out over sunlit canyon walls from the shadowed dooryard of a house. A large urn is in the foreground.

Two Girls by a Mountain Torrent. (See **The Waterfall.**) 1931, 1973.

The Venetian Lamplighter. 1924. A couple, with a nude child, float on a Venetian canal barge. The woman lights a lantern which is on top of a piling.

The Waterfall. (Also titled **Two Girls by a Mountain Torrent.**) 1931. (1973, published by Portal Publications, Sausalito, Calif. "17″ by 30″ with margins.") Two girls relax on a rock ledge overlooking a tumbling waterfall.

MISCELLANEOUS
INDIVIDUAL PRINTS AND POSTERS

The following listed prints have no special category. They were published for the print trade from murals, theatre backdrops, advertisements, calendars and other miscellaneous sources. They are all in color. Dates are given where known.

Air Castles. Vertical. 16″ by 12″. (1973, published by Portal

Publications, Sausalito, Calif. "17″ by 30″ with margins.") A youth sits on a wall high above the sea, blowing bubbles in which castles appear.

Parrish won a $1,000 prize for the original painting.

Arizona. Vertical. 11″ by 9″; 15″ by 12″. Brilliant sunshine lights a canyon between two towering escarpments. The far cliffs are bathed in orange light; the near cliffs are in purple shadow.

As the Morning Steals upon the Night. 7½″ by 7⅜″. Dark rocky cliffs are outlined against a light morning sky, on the right. A small sandy beach is in the right foreground.

This is a print from one of four stage backdrops Parrish painted for Winthrop Ames' production of Shakespeare's *The Tempest*, at the New Theatre in New York City.

Aucassin Seeks for Nicolette. Vertical. 17″ by 11½″. A lone rider sits on his white horse beside a quiet river. High mountains, with castled crags, rise above him. The sky is filled with colorful clouds.

Autumn. Vertical. 12″ by 10″. A chestnut-haired woman in blowing draperies of beige, brown and lavender, holds a basket of grapes on her left hip.

The Big Magic Scene. 7½″ by 7⅜″. In massive background rocks is a dark doorway. In the distance is a view of the sea, and at the left is a tall evergreen tree. A man in a long coat and a dark hat stands at center front, with a staff in his right hand, and with his left arm upraised.

This is a print from one of four stage backdrops Parrish painted for Winthrop Ames' production of Shakespeare's *The Tempest*, at The New Theatre in New York City.

The Booklover. (See **The Idiot (#1).**)

The Broadmoor. 1921. Horizontal. 15″ by 19″. The cream-colored Broadmoor Hotel buildings are pictured beside a lake, with high, colorful mountains rising behind them. The words, "The Broadmoor—Colorado Springs," are enclosed within a decorative foreground panel.

Canyon. Vertical. 15″ by 12″. A girl in white robes clings to rocks above a rushing stream. There are sunlit canyon walls beyond her. Similarity may be seen between this work and the cover for *Life Magazine*, March 29, 1923, which shows the far canyon wall replaced by large trees.

The Century: Midsummer Holiday Number. August. Second Prize *Century* Poster Contest, 1897. Vertical. 20″ by 15⅜″. A nude, hugging her knees, is seated on the grass in front of trees which are silhouetted against a yellow sky. She is facing west. Above, superimposed on the trees, is the title "The Century" in red, and below is the issue title and Parrish's signature. First printed as a poster by Thomas & Wylie, N.Y., 1897; also published in Paris June 1898 by Imprimerie Chaix as part of a series called *Les Maitres de l'Affiche* (Masters of the Poster). Reprints have appeared in various sizes.

Cleopatra. Horizontal. 6¼″ by 7″; 13¼″ by 15½″; and 24″ by 28″. The Egyptian queen is seated in a rose-filled barge, attended by a maid-servant, a male guard and two oarsmen.

It is believed that the original painting may have been done for C. A. Crane, of the Crane Chocolate Company.

Daybreak. Horizontal. 6″ by 10″; 11″ by 18″; and 18″ by 30″. A girl lies full-length on the floor of a portico, between two columns, with a nude youth leaning over her.

It is reported that over a million copies of this print were sold.

Dreaming. Horizontal. 10″ by 18″; and 18″ by 30″. A nude sits in profile under a large tree, beside a stream with cascading waterfalls. Quiet water in the right foreground reflects the color of the golden foliage.

The Errant Pan. Vertical. Size unknown. Pan, with his pipes, is seated on a rock in the middle of a rushing stream.

Evening (nude). Vertical. 15″ by 12″. A nude girl, with head bowed, is seated on a rock in a reflecting pool, hugging her knees.

The Florentine Fête Murals. 1921. These seventeen murals are described briefly in the Preface. It is reported (not verified) that each of these murals has been titled individually, and has been

reproduced as an individual print. Complete descriptions are un-
available, however some of them are described where they appear
in various entries in the *Guide*. (See Index, **Florentine Fête
Murals**.)

In conducting research for this book, the author found copy-
right listings of Parrish's work for the following seventeen titles. It
seems plausable that this might be the complete list of **Fête** titles,
since several of them can be verified as such. They are given here,
not as the verified listing, but as a possibility.

**Arch Encounter, Boughs of Courtship, Buds Below the Roses,
Call To Joy, Castle of Indolence, Garden of Opportunity, Jour-
ney's End, Lazy Land, Love's Pilgrimage, Rose for Reward, Roses
for Romance, Shower of Fragrance, Stairway to Summer, Sweet
Nothings, Vale of Love, Whispering Gallery, Word In Passing.**

The Garden of Allah. Horizontal. 6″ by 10″; 9″ by 18″; and 15″
by 30″. Three girls, flanked by two large urns, lounge beside a
reflecting pool. An interesting feature of this work is that the
artist's initials are reflected in the pool. This was one of the more
popular Parrish prints. It is believed that the original painting
may have been done for C. A. Crane, of the Crane Chocolate
Company.

The Garden of Opportunity (#1). 20½″ by 11″. A young couple
in medieval costume descends a short flight of steps. Mountains
rise into a summer sky behind them. In the right background is
another couple, and overhead are branches of a chestnut tree.
This is one of the **Florentine Fête Murals**.

Garden of Opportunity (#2). This is a triptych, consisting of two
side panels measuring 20½″ by 6½″ each; and a center panel
measuring 20½″ by 11″.

The center panel is **The Garden of Opportunity (#1)**.

The left panel, titled, **Love's Pilgrimage**, shows eight figures
walking from west to east beneath a balustrade. Above them,
on the balcony, a girl chats with a youth whose back is to the
viewer. Urns are on either side of the couple, and trees are in the
background.

The right panel, titled, **Call to Joy**, portrays five young people
standing before an arched panel in a wall. A maiden leans over
the balustrade above them, flanked by two urns. Dominating the

foreground is a pierrot in white, holding onto his long garments with his left hand, his right arm raised in a beckoning gesture. These are three of the **Florentine Fête Murals.**

The Gardener *(Collier's).* 1907. Vertical. 19¼" by 12¾". A gardener stands in profile against a plain white background. He wears a yellow hat, brown jacket and green trousers, and carries a hoe and a green watering can.

This print is often found with an accompanying tag stating, "Artist's Proof—'The Gardener'—by Maxfield Parrish."

Hiawatha. Vertical. Size unknown. There is reported to be a print with this title, of an Indian youth standing on a rock in a river, holding a drawn bow and arrow. Mists are below him, and above and beyond him are high, golden mountains. Unverified. (See Index, *The Song of Hiawatha*; and *Collier's Magazine*, Oct. 14, 1905.)

Hilltop. Vertical. 20" by 12"; and 30" by 18½". Two girls lie under a large tree atop a high hill. A village, a lake and mountains are below and beyond them.

Humpty Dumpty *(Life).* Vertical. 40" by 32". (1973, published by Portal Publications, Sausalito, Calif. "17" by 30" with margins.") This poster is of a smiling Humpty, dressed in high white collar and purple suit, sitting cross-legged on a wall, with a teacup and saucer in his hands. A pewter teapot rests on the wall beside him, and a tree and distant scenery are behind him.

The Idiot (#1). (Also titled **The Booklover.**) Vertical. 12" by 8½". A man dressed in black polka-dot robes is seated on a white stool, reading. The background is red.

The Idiot (#2). Vertical. 12" by 8½". A man dressed in red polka-dot robes is seated on a green stool, reading.

The Idiot (#3). Vertical. 24" by 12". Same description as (#1). Published by Eastwind Printers, San Francisco, 1967.

Interlude. 1921. Vertical. 14½" by 12". Three girls with stringed

instruments lounge beside a quiet lake. Branches from tall trees hang over them, and distant mountains loom beyond the lake. This was one of the more popular Parrish prints. Many publishers cropped it, giving it a horizontal, rather than a vertical, format. They titled the cropped version **The Lute Players**. Throughout the *Guide* the horizontal format will be referred to as **The Lute Players**; the vertical format as **Interlude**.

Jack and the Beanstalk. 19″ square. A boy with a spade kneels beneath a chestnut tree. This is one of four advertisements painted by Parrish for Ferry's Seeds.

Jack Frost. Vertical. 13″ by 12¾″. An elfin figure, wearing a purple suit, paints maple leaves in vivid colors.

Jack Spratt. Vertical. 20″ by 15″. Jack Spratt and his wife enjoy a ham in front of a large, arched window, while the little dog waits for scraps. This picture was used as an advertisement for Swift's Premium Ham.

The Lute Players. 1921 (See **Interlude.**) Horizontal. 12″ by 18″; and 18″ by 30″. Three girls with stringed instruments lounge beside a quiet lake. Branches from tall trees hang over them, and distant mountains loom beyond the lake.

Man With Apple (#1). Vertical. 14″ by 11″. A man in a red and white checked robe inspects an apple from the small tree behind him.

Man with Apple (#2). Vertical. 14″ by 11″. Same as (#1) except that the apple has been omitted.

Mary, Mary Quite Contrary. 19″ square. A young girl wearing a white dress with a wide collar and a black bodice, sits cross-legged on a flower pot, chin in hand. A green watering can is beside her. Greensward and a reflecting pond are in the lower background; the larger portion of the background consists of a cloud-filled summer sky.

This is one of four advertisements painted by Parrish for Ferry's Seeds.

Morning. Vertical. 15″ by 12″. A woman in white robes sits on a rocky, mountain slope under a cloud-filled sky.

New Hampshire—Land of Scenic Splendor. (Also titled **Thy Templed Hills.**) 1934. Vertical. 30″ by 24″. On the left two trees with brown foliage rise into a sky filled with fleecy white clouds. A quiet lake, set among brown boulders, reflects the sky. A tiny village is shown beyond the lake, with blue mountains rising above it.

This poster was created for the State of New Hampshire, Planning and Development Commission.

New Hampshire—Winter Paradise. 1934. Vertical. 28″ by 18″. This winter scene is of pink and blue snow-covered mountains, with a village below them. A tall evergreen tree dominates the rocky foreground, and shorter ones are in the distance.

This poster was created for the State of New Hampshire, Planning and Development Commission.

Old King Cole (St. Regis). 1906. Horizontal. 6½″ by 25½″. King Cole is seated on his throne in the center of a long portico. He wears an amused expression and is flanked by four smirking attendants. Two pages sit at his feet, "fiddlers three" prepare to perform on the left, while the pipe and bowl are brought in by attendants on the right.

The Phoenix Throne. 7½″ by 7⅜″. A massive boulder throws a strong purple shadow, a single tree is on the left, and a distorted rock on the right caricatures a face.

This is a print from one of four stage backdrops Parrish painted for Winthrop Ames' production of Shakespeare's *The Tempest*, at The New Theatre in New York City.

The Pied Piper. 1909. Horizontal. 6½″ by 21″. The Piper, in a red suit and a black and white checked cape, is outlined against a spreading tree. The children scramble around him. High in the mountains on the right is the distant town.

Red Cross Posters. Vertical. Set of four. Date and sizes unknown. For descriptions see p. 26, *Art and the Great War*.

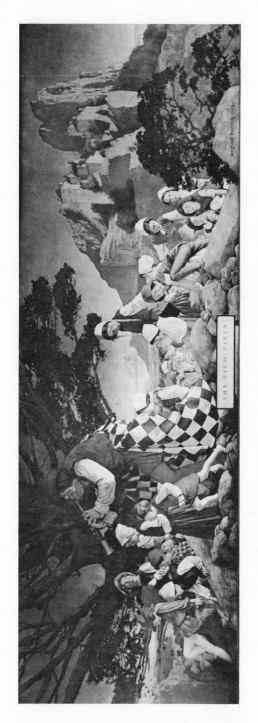

The Pied Piper Mural in the Sheraton-Palace Hotel in San Francisco, painted by Parrish 1909

Courtesy of the Sheraton-Palace Hotel

JOHN COX

HIS BOOK

Bookplate for John Cox, illustrated in the *Century* magazine,
December 1901

The Royal Gorge of the Colorado. (See also **The Spirit of Transportation.**) Vertical. 20¼″ by 14½″. The view is in a deep gorge, looking across a tumbling river which has steep cliffs rising from the opposite shore. A pine tree dominates the right foreground.

The Rubáiyát. Horizontal. 2″ by 8¼″; 3¼″ by 14½″; and 7″ by 28½″. A woman, and a man with a book in his hand, facing each other from opposite ends of the picture, are seated beneath a spreading tree. Mountain ranges glow pink in the distance. This picture illustrates the famous lines from *The Rubáiyát of Omar Khayyám*:

> Here with a loaf of bread beneath the bough,
> A flask of wine, a book of verse—and Thou
> Beside me singing in the wilderness—
> And wilderness is Paradise enow.*

It is believed that the original painting may have been done for C. A. Crane, of the Crane Chocolate Company.

Scribner's Christmas poster. 1897. Vertical. 22″ by 14″. A profile butler in a cut-away coat bears the Christmas pudding. (See *Show—The Magazine of the Arts*, May, 1964.)

Scribner's cover poster. April, 1899. Vertical. 21¾″ by 14″. A profile, robed maiden sits by a sundial. Trees and a cloudy sky are in the background.

Sing a Song of Sixpence. 1910. Horizontal. 9″ by 21″. The King and Queen are seated in large green carved chairs, at a table. The pie has just been opened and the blackbirds are singing. The King and Queen, two servants and two pages, all wear expressions of amazement.

The Spirit of Transportation. (See also **The Royal Gorge of the Colorado.**) Vertical. 5½″ by 4″; and 20¼″ by 14½″. The view is in a deep gorge, looking across a tumbling river, which has steep cliffs rising from the opposite shore. A pine tree dominates the

The Rubáiyát of Omar Khayyám, trans. Edward Fitzgerald. New York, 1937.

right foreground. Two little trucks appear high on the far cliffs. It is reported that this print was used for a calendar by the Clark Equipment Company, of Buchanan, Michigan, date unknown. The scene differs from **The Royal Gorge of the Colorado** only in the addition of the two trunks.

Stars. Vertical. 10″ by 6″; 20″ by 12″; and 30″ by 18″. A nude girl sits in profile in the dark, knees drawn up and head back, looking at the stars.

Title Unknown. Vertical. 11″ bv 9″. A young woman wearing green draperies, swings in a swing. (See *Collier's Magazine*, July 21, 1906.)

Title Unknown. 7½″ by 7⅜″. This scene appears to be inside of a rocky, seaside cave which has a smooth, sandy floor. Two apertures give glimpses of cloudy sky and a blue sea.

This is a print from one of four stage backdrops Parrish painted for Winthrop Ames' production of Shakespeare's *The Tempest*, at The New Theatre in New York City.

Toyland. (Also titled **The Toy Show—Holiday Bazaar.**) Vertical. 28″ by 22″. Two comic soldiers stand at attention on opposite sides of a view of a distant town. (See *The Children's Book.* Horace E. Scudder, ed. Boston: Houghton Mifflin Co., 1907, 1909; and *Collier's Magazine*, July 3, 1909.)

The Wassail Bowl. Vertical. 3½″ by 2½″. A bold male figure in blues and greens strides along, bearing a steaming silver bowl. A landscape is visible through the circular window behind him. (See *Collier's Magazine*, Dec. 11, 1909.)

White Birch. Vertical. 11″ by 9″. A farmer plows with a team of white horses, beneath a tall white birch tree.

Wild Geese. Vertical. 15″ by 12″. This scene is in a rugged mountain setting. A girl lying on her stomach by a pool, has raised her head to look into the sky. The geese must be imagined as none appear in the picture.

ILLUSTRATIONS
IN BOOKS

Included in this section are books wholly, or partially, illustrated with Parrish's work.

Albert I, King of Belgians. The Daily Telegraph, ed. London: Knights of London, 1915. Hearst's Int. Lib., 1915, p. 112. Color illustration, **Dies Irae**, from *Dream Days.*

An Album of Brandywine Tradition Artists. New York: Great American Editions, 1971, p. 30. Black and white illustration, **Very Little Red Riding Hood.** Red Riding Hood stands in a forest. She wears a bonnet with flowing ties, a generous cape, and is carrying a basket.

American Art By American Artists; One Hundred Favorite Paintings. New York: P. F. Collier & Son, sixteen editions between 1898 and 1914. Eleven color plates by Parrish, 16" by 12": **Atlas, Bellerphon by the Fountain of Pirene, Cadmus, Jason and his Teacher, Pandora,** and **Proserpina,** from *The Wonder Book;* **Aladdin, Cassim, Prince Codadad, Queen Gulnare,** and **The Young King of the Black Isles,** from *The Arabian Nights.*

American Arts. Rilla Evelyn Jackman. Chicago: Rand McNally & Company, 1928, pp. 34-35, 276-79. Double-page black and white illustration, **The Dream Garden.** Text on Parrish.

American Pictures and Their Painters. Lorinda M. Bryant. New York and London: John Lane, 1917, pp. 257-59. Three black and white illustrations from the **Florentine Fête Murals: Call to Joy, The Garden of Opportunity (#1),** and **Love's Pilgrimage.**

The American Poster. The American Federation of Arts. New York: 1967, pp. 14-15.

Two black and white illustrations: one of the poster, *Century Magazine* Midsummer Holiday Number, August, 1897; and one of the poster, *Scribner's* Fiction Number, August. Short text on the artist.

The Annotated Mother Goose. William S. Baring-Gould and Cecil Baring-Gould, eds. New York: Clarkson N. Potter, Inc., 1962, pp. 142, 191, 214, 221, 225, 285, 290, 292, 311, 318, and 330. Eleven black and white line and stipple illustrations from *Mother Goose In Prose.*

The Annual of Advertising Art in the U.S.—1921. New York: Publishers Printing Co., 1921.

Five black and white illustrations: p. 22, **Prometheus**; p. 29, **And Night is Fled**; p. 36, Djer-Kiss cosmetics advertisement, of a girl in a swing, with bowers of roses over her head, and mountains in the distance; p. 47, **The Spirit of Transportation**; p. 91, **Primitive Man**.

The Second Annual of Illustrations for Advertisements In the United States. New York: The Art Directors Club, 1923. Two black and white illustrations, p. 76, p. 161, both of **Egypt**.

Third Annual of Advertising Art. New York: The Art Directors Club, 1924. Three black and white illustrations: p. 46, **The Venetian Lamplighter**; p. 47, **The King and Queen**, and **Polly Put the Kettle On**.

Fourth Annual of Advertising Art. New York: The Art Directors Club, 1925. Three black and white illustrations: p. 8, **Dreamlight**; pp. 37, 124, both are the Edison-Mazda design of two youths chatting above a central panel, one toys with a light bulb.

The Arabian Nights. Kate Douglas Wiggin and Nora A. Smith, eds. New York: Charles Scribner's Sons, 1909.

Twelve illustrations (some editions contain only nine), title page, end papers and paste-on cover are all in color. The twelve illustrations have been published as larger-than-book-size

prints, but as far as is known the cover and end papers have not. The cover print is 8¼″ by 6½″, divided into two sections. The upper section bears the title information. The lower section depicts a muscular man leaning against the weight of a load he is pulling with a long rope. Boulders are around him, and beyond him are seen a purple sea, and a colorful sky and clouds.

The end papers portray shadowed rocks in front of a brown, spreading tree which is silhouetted against an orange sky.

The book size of the remaining illustrations is uniform, 6½″ by 5½″; the print size is uniform, 11″ by 9″. All are vertical.

Aladdin. p. 106. A small, startled boy and an evil-looking man stand beside a black cloud issuing from the earth.

The Brazen Boatman. (Also titled **The Landing of the Brazen Boatman.**) p. 194. A man descends wide steps from between two immense pillars. A bronze figure in a graceful boat awaits him. Parrish won the Beck Prize for the original painting. (See *International Studio*, April, 1909.)

Cassim. p. 236. A spotlighted male figure sits in a dark cave, surrounded by pottery jars and metal trays.

The City of Brass. p. 218. Three small horsemen gaze up into the clouds at the high and distant city of brass.

The Fisherman and the Genie. p. 54. A startled fisherman stares at a black cloud rising from the small container at his feet.

Gulnare of the Sea. (Also titled **Queen Gulnare.**) p. 86. A robed woman wearing a crown, bends over pottery urns.

The Landing of the Brazen Boatman. (See **The Brazen Boatman.**)

The Pirate Ship. (See **Prince Codadad.**)

Prince Agib. (Also titled **Story of a King's Son.**) p. 202. A man carrying a large ring of keys, stands beside a small, round pool. He is framed by two large urns.

Prince Codadad. (Also titled **The Pirate Ship.**) p. 276. A sailing ship, complete with several pirates, approaches.

Queen Gulnare. (See **Gulnare of the Sea.**)

The Search for the Singing Tree. (Also titled **The Talking Bird.**) p. 32. A figure in blowing red garments stands on a mountaintop, holding aloft a small, leafy branch.

Sinbad Plots Against the Giant. (Also titled **Sleeping Giant.**) p. 306. A seated giant, with bushy black hair, dozes in a room with orange walls. A group of four little men stand nearby.

Sleeping Giant. (See **Sinbad Plots Against the Giant.**)

The Talking Bird. (See **The Search for the Singing Tree.**)
The Valley of Diamonds. p. 300. A solitary man stands in a
rocky, mountain fastness.
The Young King of the Black Isles. p. 74. A figure in royal blue,
seated on a simple yellow throne, has his head bowed on his
arm in a posture of woe.

Art and the Great War. Albert Eugene Gallatin. New York:
E. P. Dutton and Co., Inc., 1919.
In the unnumbered picture section are three pages in black and
white, of Red Cross posters by Parrish.
One page illustrates the four posters, shown in vertical format,
two above and two below. Together, it is obvious that one back-
ground sky encompasses all four posters. The two upper posters
each have a Red Cross symbol shown against the sky, with the
cloud formation being different behind each symbol. One of the
lower posters is of a young Red Cross worker distributing food to
children, as an old man watches. The other lower poster is of a
Red Cross nurse and a wounded soldier, aboard ship. The four
posters are vertical in format.
The remaining two pages are enlargements of the two lower
posters.

Bolanyo. Opie Reed. Chicago: Way and Williams, 1897. Chicago:
Rand McNally, 1902.
Embossed cover design in color of an Edwardian gentleman
with his cigar. A village is in the background.

*Book Illustration; A Survey of Its History and Development
Shown by the Work of Various Artists, Together With Critical
Comments.* Richard Williamson Ellis. Kingsport, Tennessee: The
Kingsport Press, 1952. Reported to contain illustration from
Dream Days. Further information unavailable. Unverified.

The Brandywine Tradition. Henry Clarence Pitts. Boston:
Houghton Mifflin Company, 1969, pp. 97, 145, 222-23. Between
pp. 222-23 is a black and white illustration of the poster, *Scrib-
ner's* Fiction Number, August. Short texts on Parrish, pp. 97, 145.

A Cavalcade of Collier's. Kenneth McArdle, ed. New York: A. S.
Barnes & Co., 1959. A small black and white illustration, **The**

Page, from *The Knave of Hearts*, is in the picture section at the front of the book.

The Children's Book. Horace E. Scudder, ed. Boston: Houghton Mifflin Co., 1907, 1909.
Paste-on cover design, in color, of two comic soldiers standing at attention on opposite sides of a view of a distant town. (See also *Collier's Magazine*, July 3, 1909; and **Toyland**.)

A Collection of Colour Prints By Jules Guerin and Maxfield Parrish. Cleveland: J. H. Jansen, n. d.
Incomplete inventories from The Cleveland Museum of Art, and The Metropolitan Museum of Art, have been combined to produce the following list of Parrish prints contained within this volume. At present there is no way of knowing whether it is complete. Titles are given here as they were submitted by the museums:
Boboli Garden, Florence; Gardens of Isola Bella; Gardens of Villa Gori; Lake Maggiore; The Little Princess; The Pool, Villa D'Este; The Sandman; Seven Green Pools of Cintra; The Valley; Villa Chigi; Villa Cicogna; Villa D'Este; Villa Gamberaia; Villa Medici; Villa Scassi (2 different views).

Collector's Guide To Maxfield Parrish. Harold Knox. W. Lebanon, N.H.: Harold Knox, 1972.
Cover in color consisting of a decorative, scrolled design around a landscape of rocks, a stream, trees and background mountains. Above the landscape, enclosed within a circle, is an illustration of the "Old Man of the Mountain," a natural stone profile, which is on Cannon Mountain, in Franconia Notch, New Hampshire.
Fifteen black and white illustrations and photographs, most of them of one-of-a-kind items from Mr. Knox's personal collection.
Biographical and bibliographical material.

Dream Days. Kenneth Grahame. New York and London: John Lane, 1898, 1902.
Nine black and white line and stipple illustrations, title page and many tailpieces.
As far as is known the reproductions of these illustrations are

as follows: calendar prints, advertised in the *International Studio*, Feb., 1908, for which no further information is available at this writing; the color illustrations of **A Departure, Dies Irae, Its Walls were as of Jasper (#2)**, and **The Reluctant Dragon**, published by *The Illustrated London News* (see Illustrations In Periodicals); and in 1973 **The Reluctant Dragon** was reprinted by Portal Publications, Sausalito, Calif., "17″ by 30″ with margins."

The page size of the book is 8″ by 6″ and the vertical illustrations vary in size within this measurement.

Title Page. A pleasant-looking giant, with his staff and checked knapsack, sits surrounded by leaves, talking to a small boy. A Castle is in the background.

A Departure. p. 207. A smiling "man in the moon" looks down through tree branches at three small children who are stealing through the shrubbery in their night clothes. One child carries a shovel.

Dies Irae. p. 25. A boy dressed in a black hat, cape and sword, sits astride a horse. He is attended by two henchmen carrying huge banners, and a page bearing a battle-axe.

Its Walls Were as of Jasper (#1). (Two illustrations in the book bear this title.) Frontispiece. A small boy climbs into the picture from the lower left corner. Before him is a flower-strewn hillock, and beyond are armed knights on horses, a sailing vessel in the harbor, and a city of castles rising into the sky.

Its Walls Were as of Jasper (#2). p. 97. A small boy, in a sailor suit and hat, sits on the edge of the picture in the lower left corner. From the quiet sea before him rises a castled island.

The Magic Ring. p. 71. A man in a top hat and formal attire stands with feet crossed, leaning on a long buggy whip. A jeering clown, clutching baggy white trousers, points a finger at the first man.

Mutabile Semper. p. 47. A small boy stands in a boat of Viking design. The bow and stern represent the head and tail of a seahorse. The child is gazing up at an elaborate doorway, over which is the word "chocolate." Chefs on either side of the doorway bear trays of chocolates.

The Reluctant Dragon. p. 149. A benign-looking dragon sits on its haunches, talking with a young boy. Houses rise against the hill beyond them.

A Saga of the Seas. p. 123. A small boy and a towering pirate engage in a sword fight on the deck of a ship.

The Twenty-First of October. p. 3. A gardener, with his watering can and hoe, is angrily shaking his fist.

The Emerald Story Book. Ada M. and Eleanor L. Skinner. New York: Duffield & Company, 1917. Frontispiece in color, title unknown, of a young woman wearing green draperies, swinging in a swing. (See *Collier's Magazine* cover, July 21, 1906.)

Free To Serve. Emma Rayner. Copeland & Day, 1897. Embossed cover design in color, of a man standing before a fireplace, holding a sign which bears the author's name.

The Garden of Years and Other Poems. Guy Wetmore Carryl. New York and London: G. P. Putnam's Sons, 1904. Frontispiece in color, title unknown, of a distant view of water and yellow clouds, seen through a rose garden.

A Generation of Illustrators and Etchers. Loring Holmes Dodd. Boston: Chapman & Grimes, Inc., 1960, pp. 87, 91-95. Black and white illustration, **Its Walls Were as of Jasper (#2)**, from *Dream Days*. Text on Parrish.

The Golden Age. Kenneth Grahame. New York and London: John Lane, 1899.
Eighteen black and white line and stipple illustrations, title page and many tailpieces. As far as is known these illustrations were not published as separate prints. The page size is 8" by 6" and the vertical illustrations vary in size within this measurement.
Title Page. A youth sits on the frame of the picture, looking over his right shoulder at a castled town which is isolated atop a rocky column in a vast, dark canyon.
"At breakfast Miss Smedley behaved . . .", p. 196. Two children and a young woman sit at a table. The woman has her hat on, and appears to be crying into her handkerchief. Through the window behind her is a view of trees.
"But yester-eve the mummers were here!" p. 122. A man dressed in a black hat, figured robe and buckled boots, holds a pole from which a large banner waves behind him.

"Finally we found ourselves sitting . . .", p. 250. Two boys sit
dejectedly on an upturned wheelbarrow. Part of a house and dis-
tant fields are seen beyond them.

"For them the orchard (a place elf-haunted, wonderful!) . . .",
p. 2. A large tree trunk is on the left. On the right, two gnomes
walk through the forest, one bearing a cask on his shoulders, the
other carrying a staff.

"A great book open on his knee . . ." p. 112. A man in a
wicker chair sits in the open door of a library. A lad sits on a
stool in the right foreground.

"I drew it out and carried it to the window . . ." p. 186. A
small boy, holding a little box, stands before a wooden window-
bench. Through the window's small panes can be seen a brick
house and several trees.

"I'm Jason, . . . and this is the Argo . . ." p. 146. A boy in a
plank boat uses a shovel for a paddle. Wooded cliffs rise beyond
him.

"I took the old fellow to the station . . ." p. 34. A man in a top
hat, with a cigar and umbrella, strides along the street, accom-
panied by a small boy in a white suit and hat. The village lies
behind them.

"It was easy . . . to transport yourself . . ." p. 68. A boy
carrying a huge flintlock gun, and with a pistol in his belt, creeps
through the trees.

"Lulled by the trickling of water . . ." p. 62. In front of a
rambling house with its gardens, a small boy studies himself in a
lily pond.

"Once more were damsels rescued . . ." p. 40. A lad in chain
mail, with a sword and shield, attacks a monstrous serpent.

"On to the garden wall, . . ." Frontispiece. Two boys in their
nightshirts scramble along the top of a brick wall in the moon-
light. Tree branches are behind them.

"Out into the brimming sun-bathed world . . ." p. 14. A boy
climbs over a board fence. Meadows, trees and a village are seen
behind him.

"The procession passed solemnly . . ." p. 218. A pop-eyed
boy sits up in bed, staring straight ahead.

"They make me walk behind, . . ." p. 138. A little girl stands
wistfully before a gateway in a wall.

"Who would have thought . . ." p. 84. A spraddle-legged man

stands behind a hedge, holding a large stick in a threatening gesture.
"Why, Master Harold!" p. 232. A man in a buggy, with the
reins and a buggy whip in his hands, accosts a small boy who is
crying. There are two versions of this picture. In the 1899 edition
of the book, the driver is dressed in casual farm clothes, wearing a
drover's hat and smoking a pipe. In later editions of the book, the
driver is dressed more formally, with a long coat, a top hat, and
no pipe.
"You haven't been to Rome, have you?" p. 166. (Also titled
The Roman Road.) An artist, with palette, stands before a small
boy. A walled village rises behind them.

The Golden Age of the Poster. Hayward and Blanche Cirker, eds.
New York: Dover Publications, Inc., 1971, p. 51. Illustration in
color of poster, *Century Magazine* Mid-summer Holiday Number,
August, 1897.

The Golden Treasury of Songs and Lyrics. Francis Turner Pal-
grave. New York: Duffield & Company, 1911. New York: Garden
City Publishing Co., Inc., 1941. (The latter edition contains only
four of the eight illustrations for the book; **Harvest, The Lantern
Bearers, Summer,** and **Three Shepherds**.)
 The Duffield & Company, 1911, edition contains eight vertical
illustrations and paste-on cover, in color; plus black and white
end papers. All eight illustrations were published as larger-than-
book-size prints.
 The cover print is **Spring**, which also appears in the book, p. 312.
 As far as is known the end papers have not been reproduced
as an individual print. Their design, used on several Collier's
publications, consists of two robed figures facing each other over
a central panel.
 Autumn. Frontispiece. Book size 7¼" by 5". Print size 11½" by
9½". A chestnut-haired woman in blowing draperies of beige,
brown and lavender, holds a basket of grapes on her left hip.
 Easter. p. 326. Book size 7¼" by 5". Print size 12" by 9¾". A
nude boy kneels in profile at the base of a large tree trunk. He
holds a bouquet of Easter lilies and is outlined against a full
white moon.
 Harvest. p. 130. Book size 7⅛" by 5". Print size 11¾" by 9¾". A
man with a scythe is silhouetted against an orange sky.

The Lantern Bearers. p. 38. Book size 6¼″ by 5″. Print size 11½″ by 9½″. Six pierrots are hanging orange lanterns in a tree.
Pierrot's Serenade. p. 216. Book size 7⅛″ by 5″. Print size 11″ by 9½″. Pierrot, with mandolin, is seated on a wall beneath the spreading branches of a tree. The yellow sky is reflected in the lake beside him.
Spring. p. 312. (This is also the cover illustration.) Book size 7⅛″ by 5″. Print size 11¾″ by 9¾″. A blond girl, robed in pink, strides through spring flowers.
Summer. p. 110. Book size 7⅛″ by 5″. Print size 11″ by 9½″. A nude youth sits on a boulder by a forest stream. He holds a set of Pan pipes. This picture is in monotone green.
Three Shepherds. p. 54. Book size 6¼″ by 5″. Print size unknown. Three shepherds look to the sky. A small fire burns at their feet; tree branches intrude in the upper right corner. (See also *Collier's Magazine* cover, Dec. 3, 1904.)

Graphic Arts and Crafts Yearbook 1907. Joseph Meadon, ed. Hamilton, Ohio: Republican Publishing Co., 1907. Two color illustrations: p. 72, "Venice—Twilight;" p. 90, **Harvest**.

The History and Ideals of American Art. Eugene Neuhaus. Stanford, Calif.: Stanford University Press, 1931, p. 366. Black and white illustration of **Call to Joy** from the **Florentine Fête Murals**. Short text on Parrish.

The Illustrated Book. Frank Weitenkampf. Cambridge, Mass.: Cambridge Harvard University Press, 1938, pp. 219, 221. Black and white illustration of **Prince Codadad**, from *The Arabian Nights*. Small paragraph on Parrish.

The Illustrator In America 1900—1960's. Walter Reed, ed. New York: Reinhold Publishing Corporation, 1966, p. 64.
 Two black and white illustrations: **The Wond'rous Wise Man**, from *Mother Goose In Prose*; and **Jason and the Talking Oak**, from *The Wonder Book*.

The International Library of Music. New York: The University Society of New York, 1925, vol. II, pp. 524, 534.
 Two black and white illustrations: Berceuse (see *Century*

Magazine, Dec., 1898); and Inspiration (see *Century Magazine,* Dec., 1899).

The volume containing Study Material, Grade Three (volume number unknown), contains a black and white frontispiece, **A Journey Through Sunny Provence,** from *Troubadour Tales.*

Italian Villas and Their Gardens. Edith Wharton. New York: The Century Co., 1915.

Fifteen color illustrations, eleven black and white illustrations. Various combinations of selected illustrations from this book were published as art portfolios, and those known are book size. (See Miscellanea, Art Portfolio.) Page size is 10⅜" by 7" and the pictures vary in size within this measurement. The illustrations are listed alphabetically by their titles. All of them are various aspects of villas and gardens in Italy.

Color:

Boboli, p. 24.

Cicogna, p. 196.

Gamberaia, p. 39.

In the Gardens of Isola Bella,
 p. 210.

Isola Bella, p. 203.

Pliniana, p. 221.

The Pool, Villa D'Este, p. 141.

The Theatre at La Palazzina,
 p. 73.

Vicobello, p. 62.

Villa Campi, frontispiece.

Villa Chigi, p. 111.

Villa D'Este, p. 126.

Villa Gori, p. 67.

Villa Medici, p. 100.

Villa Scassi, p. 172.

Black and white:

The Cascade, Villa Torlonia (also titled **Torlonia**), p. 9.

Corsini, p. 49.

The Dome of St. Peter's, p. 80.

A Garden-Niche, p. 181.

Gateway of the Botanic Gardens, Padua, p. 230.

The Reservoir at Villa Falconieri, p. 4.

Val San Zibio, p. 241.

View at Val San Zibio, p. 235.

Villa Lante, p. 146.

Villa Pia, p. 105.

Vilmarana, p. 247.

The Junior Classics, vols. II & III. New York: P. F. Collier &

Sons, 1912. Vol. II: color frontispiece, **Pandora**. Vol. III: color frontispiece, **Circe's Palace**. Black and white illustrations; p. 66, **The Argonauts in Quest of the Golden Fleece**; p. 98, **Jason and the Talking Oak**; and p. 130, **The Centaur**. (All the preceding reprinted from *The Wonder Book*.)

The Knave of Hearts. Louise Saunders. Boston: The Atlantic Monthly Press, 1921; New York: Charles Scribner's Sons, 1925; Racine, Wisconsin: Artist and Writers Guild, n.d. (spiral bound edition).

The twenty-three illustrations from this book are so delightful that one is apt to find any of them framed. They are all in color. **The Page, The Prince** and **Romance** are the only ones known to have been published as single prints.

The hard bound edition has end papers which were published as the single print, **Romance**. The spiral bound edition has no end papers or page numbers, and bears the cover design on the front, and on the back, of the book.

Some of the illustrations appear to have no formal titles. Those assigned by the author for identification purposes are printed in lower-case letters.

Cook with Steaming Pot of Soup. Horizontal. p. 13. 4½″ by 9¼″. A cook, carrying a steaming copper kettle, strides along in front of three arched windows.

The Court Jester. Horizontal. p. 37. 4½″ by 9¼″. A jester, with bells on his green costume, sits with his lute on a low wall. A branch of a chestnut tree intrudes from above.

Dramatis Personae. Vertical. n.p. 12″ by 9¾″. Two pages in purple hold the list of the cast of characters between them.

The End (also titled "The Best is Yet to Come.") Vertical. Facing p. 46. 12″ by 9¾″. A bowing figure in red is enclosed in a full circle. Beneath his feet are the words, "The End." (See *Collier's Magazine* cover, Jan., 1929)

The Entrance of the King. Vertical. Facing p. 14. 12″ by 9¾″. Military attendants with golden trumpets stand on either side of an archway through which the King, in full regalia, is entering.

The Gardener (*Knave of Hearts*). Horizontal. p. 29. 4½″ by 9¼″. A man with a wheelbarrow loaded with vegetables is outlined against distant purple and lavender mountains.

The King and the Chancellor. Vertical. Facing p. 30. 12″ by 9¾″. The Chancellor, in black and white checked robe, knocks on a door. The King, in purple robes, awaits beside him.

The King Samples the Tarts. Vertical. Facing p. 38. 12″ by
9¾″. The King samples tarts offered by a cook. The Chancellor,
in black and white checked robes, stands by.

Lobsters With Cook. Horizontal. p. 17. 4½″ by 9¼″. Two large,
red lobsters make a seat with their claws for a smiling cook. (See
also *Collier's Magazine* cover, Nov. 26, 1910.)

The Manager. Horizontal. Facing p. 5. 7½″ by 9¼″. A figure in red
draws aside a green stage curtain to reveal a glimpse of countryside.

Musician Playing Lute. Horizontal. p. 41. 4½″ by 9¼″. A
minstrel plays a lute beside a circular pool, surrounded by
flowers and trees.

The Page. Vertical. Facing p. 42. Book and print size are 12″
by 9¾″. A youth, wearing a purple cape and a red hat with a
feather in it, sits on a wall. Behind him is a tree in green foliage,
and beyond him distant castles rise into a colorful, cloudy sky.
(See also *Collier's Magazine* cover, May 11, 1929.)

Potato Peelers. Horizontal. p. 33. 4½″ by 9¼″. Two cooks
peel potatoes over a large purple kettle.

The Prince. Vertical. Facing p. 34. Book and print size 12″ by
9½″. A youth lounges on the flower-strewn grass near an arched
bridge. Gnarled, spreading tree branches and a view of a distant
mountain gorge, are beyond him.

Romance. Horizontal. End papers. Book and print size 12¾″
by 24″. A shadowed parapet is in the foreground. A young man
stands on the left, a young woman on the right. High sunset-
lighted mountains, and a castle, are in the background. (The spiral
bound edition does not contain this picture.)

Six Cooks. Vertical. Facing p. 22. 12″ by 9⅝″. Six identical
cooks bear identical green bowls on trays. Above their heads is
a design with three hearts and two roosters.

This Is The Book Of. Vertical. n.p. 12″ by 9¾″. This is the
bookplate which appears in the front of the book. A man sits
reading beneath a large tree, surrounded by piles of books. The
picture is enclosed in a complete circle. Beneath the circle, within
a rectangular frame, are the.words, "This Is The Book Of." A
page sits at either end of this frame.

Title Page for *The Knave of Hearts.* Vertical. n.p. 12″ by
9¾″. This illustration consists of a symmetrical, theatrical design
around the printed material. At the top is a mask, with a jester on
either side of it. On the sides, halfway down the page, two youths
sit on parts of the design. At the bottom are hearts and small
landscapes, enclosed within the design.

Two Cooks With Checkerboard Background. Horizontal. p. 10.
4½″ by 9¼″. Two cooks, with utensils, stand in front of a checker-
board background.

Two Cooks With Spoons. Vertical. Facing p. 10. 12″ by 9¾″.
Two cooks, holding outsize spoons, pose before a cabinet on
which are three large bowls. Over their heads is an ornate clock.

Two Cooks With Spoons (cover design). Vertical. 12″ by 10¼″.
Two cooks, holding outsize spoons, pose before an archway
through which are seen castles on a high mountain.

Violetta. Vertical. n.p. 12″ by 9¾″. A girl in medieval costume
stands by a low cupboard with a pitcher in her hand. She is
framed by the foliage of trees seen through the window behind
her.

Violetta and the King. Vertical. Facing p. 18. 12″ by 9¾″. A
woman in golden garments kneels before the King, with her face
buried in her hands. The King leans forward on his throne.

Violetta and the Knave. Vertical. Facing p. 26. 12″ by 9¾″. A
young woman kneels, peering into an oven. A youth stands be-
side her. A shelf of large pewter pieces crosses the top of the pic-
ture.

Youth Talking to a Frog. Horizontal. p. 21. 4½″ by 9¼″. A
youth standing beside a lake, leans forward to look down at a
large, green frog. Tree foliage on either side, and low mountains,
are seen in the distance.

Knickerbocker's History of New York. Washington Irving. New
York: Robert Howard Russell, 1900, 1903; eight black and white
line and stipple illustrations (printed on the page). New York:
Dodd, Mead & Co., 1915; eight black and white line and stipple
illustrations (tipped in).

As far as is known the illustrations were not published as
separate prints. Book size of all the prints is 9″ by 6½″. All are
vertical in format.

Both editions bear a paste-on cover, 9″ by 6″, in black, cream
and gold, showing the book title above, and the publisher be-
neath, a line and stipple drawing of two men seated on benches,
facing each other. They wear broad-brimmed hats, buckled
shoes, and hold large pipes.

"Blacksmiths . . ." p. 140. The smith stands gesturing before

the open door of his shop. Through its window, and behind him, can be seen houses and trees.
Concerning Witchcraft. p. 188. A witch rides her broom beneath a full moon.
Father Knickerbocker. Frontispiece. A man in early Dutch costume sits on the branch of a tree, looking toward the tall buildings of New York City.
"The first movement of the governor . . ." p. 278. A man wearing a cape is seated astride the ridge of a roof, shaking his fist in the air.
"Phalanx of oyster-fed Pavonians . . ." p. 238. Two men in early Dutch costume, carrying blunderbusses, walk gaily along, draining their copious beer mugs.
Saint Nicholas. p. 44. A man in a white robe with a black hood, considers the large pipe in his hand.
"They introduced among them . . ." p. 25. An Indian, standing before a wall on which rests a demi-john, puckers his mouth after a drink of liquor.
Wouter Van Twiller. p. 81. A man with a great paunch covered with a bib, is seated at a table before a large bowl and a coffee pot. A sour-looking man, with hat and book in hand, stands beside him.

The Ladies' Home Journal Treasury. John Mason Brown, ed. New York: Simon & Schuster, 1956, p. 130. Color illustration for Edison-Mazda advertisement, **And Night is Fled**.

Letters and Lettering. Frank Chouteau Brown. Boston: Bates & Guild Company, 1902, 1921; pp. 106, 126. Examples of Parrish's lettering.

A Loiterer In New York. Helen W. Henderson. New York: George H. Doran, Co., 1917, p. 452. Black and white illustration, **Quod Erat Demonstrandum**.

Los Angeles Architectural Club; Yearbook—1911. Los Angeles: Los Angeles Architectural Club, vol. unpaged. Two black and white illustrations: **The Idiot (#1)**; and *Collier's Magazine* cover, Jan. 2, 1909, "- - - Plans for 1909."

The Lure of the Garden. Hildegarde Hawthorne. New York: The Century Co., 1911, p. 62.
Color illustration, **I'm Sick of Being a Princess** (also titled **The Little Princess**.) A little girl is seated on the edge of a round, raised pool, beneath a cypress tree. Her nurse stands nearby.

Modern Illustrating, Division 12. Charles L. Bartholomew and Joseph Almars, eds. Minneapolis: Federal Schools, Inc., 1931-42, pp. 22, 24. Two black and white illustrations; **Air Castles**, and an unidentified illustration from *Poems of Childhood.*

Mother Goose In Prose. L. Frank Baum. Chicago: Way and Williams, 1897. (There are several editions of this book.)
These are Parrish's first book illustrations. There are twelve vertical black and white line and stipple drawings, a title page, and headpieces. (One edition of the book contains the illustrations printed in red, instead of in black.)
The only known separate prints from this book were published as an art portfolio of signed proofs. Rare. (See Miscellanea, Art Portfolio.)
The page size is 9¼″ by 6¾″, and the drawings vary in size within this measurement.
TITLE PAGE. Two male figures in medieval dress lean on their elbows upon a desk between them. Beyond them are trees and town houses.
The Black Sheep. p. 48. A man surrounded by tree trunks, and leaning on a brick wall, looks down at a black sheep.
Humpty Dumpty (*Mother Goose*). p. 212. Humpty is seated on a wall, above the initials, "H. D." The town rises behind him.
Jack Horner. p. 102. Jack sits on a low chair by the fireplace, bowl in hand. Three large plates and a bean pot rest on the mantel.
Little Bo-Peep. p. 156. A barefoot girl in a simple dress rests her shepherd's crook within the circle of her right arm. A small tree and many clouds are in the background.
Little Boy Blue. p. 36. Boy Blue sleeps against the roots of a large tree. A village and castles are in the distance.
The Man in the Moon. p. 112. A man sits on the lower edge of a full moon, which fills the top half of the picture. One of his legs is drawn up, the other dangles over the village landscape.

The Black Sheep, one of Parrish's first book illustrations, which appeared in L. Frank Baum's *Mother Goose in Prose*, 1897

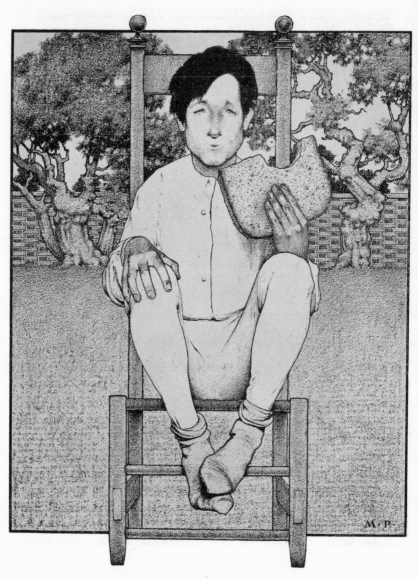

Tommy Tucker, another of Parrish's first book illustrations from *Mother
Goose in Prose*. The drawing also appeared in *Brush and Pencil*, 1898

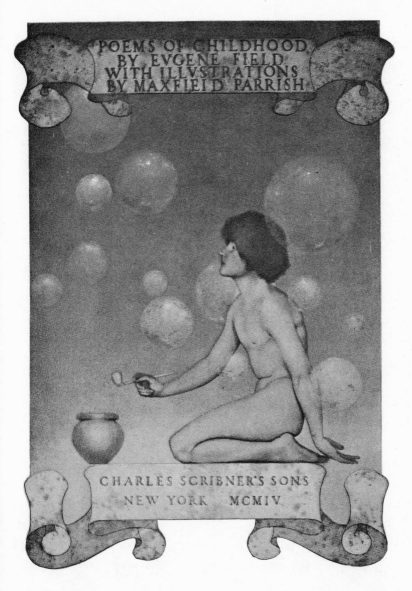

Title Page design by Parrish for *Poems of Childhood* by Eugene Field, 1904

The Dinkey Bird, one of Parrish's illustrations for *Poems of Childhood*, published in 1904

Old King Cole (*Mother Goose*). p. 68. A smiling King Cole sits on an angular throne, with a figured tapestry hanging above him, and an arched design behind him.

There Was a Little Man. Frontispiece. A little man wearing a top hat, stands in front of a spreading tree, with a blunderbuss in his hands.

There Was a Little Man. Same as previous description, in color. This is the paste-on cover design for the Bobbs-Merrill Co., 1905 edition.

The Three Wise Men of Gotham. p. 248. Three men, dressed in robes, are seated on the rim of a large bowl.

Tom, the Piper's Son. p. 200. Tom is bending over, braced with one hand on his knee, beckoning with the other hand. Part of the village can be seen above the wall behind him.

Tommy Tucker. p. 166. Tommy sits on a low, straight-backed chair, eating an immense slice of bread. A brick wall and trees are in the background.

The Wond'rous Wise Man. p. 92. A bald man dressed in robes sits with his chin in his hand beside a bookcase. A bellows hangs from the bookcase.

Mural Painting In America. Edwin H. Blashfield. New York: Charles Scribner's Sons, 1913, p. 205. Black and white illustration of **Buds Below the Roses** from the **Florentine Fête Murals**.

The New Standard Letterer and Show-Card Writer. Maxwell L. Keller. Chicago: Laird & Lee, Inc., 1926, p. 159. Small black and white illustration, *Century Magazine* Midsummer Holiday Number, August, 1897.

Norris, Frank: Collected Works. New York: P. F. Collier & Son. These volumes have a Parrish design in sepia on the title pages, which consists of two robed figures leaning over a central panel. This design was used on several *Collier's Magazine* covers.

The Pageant of America. Frank Jewett Mather, Jr., Charles Rufus Morey and William James Henderson, eds. New Haven: Yale University Press, 1927, vol. XII, p. 302. Black and white illustration, **Its Walls Were as of Jasper (#1)**, from *Dream Days*. Small paragraph on the artist.

The Pearl Story Book. Ada M. and Eleanor L. Skinner. Publishing data unavailable. Frontispiece in color. Description unavailable.

Peterkin. Gabrielle E. Jackson. New York: Duffield & Co., 1912. Frontispiece and paste-on cover are the same color illustration, **Peterkin** (also titled **April Showers**). A small boy stands under a large green unbrella. (See also *Collier's Magazine* cover, April 3, 1909.)

Poems of Childhood. Eugene Field. New York: Charles Scribner's Sons, 1904.

Eight vertical illustrations, frontispiece, end papers and paste-on cover, all in color. The eight illustrations have been published as larger-than-book-size prints on pebble-finish paper, but as far as is known the cover, the frontispiece and the end papers have not.

The cover print, 8¾″ by 6¼″, is of a giant in purple tunic and shoes, sitting on a rock, looking incredulously at a youth in white, who stands before him with a long sword. The title information is contained within a decorative banner across the top of the picture.

The title page shows a kneeling youth, with a golden bowl and a bubble pipe. Large bubbles float against a pale blue background.

The end papers depict a giant in black tunic and hood, club raised over his head, astride a great red lobster. A small youth in a black jerkin swings his sword in defense, as he stands within the grasp of one of the lobster's claws.

The Dinkey Bird. p. 120. Book size 7⅜″ by 5″. Print size 15½″ by 10¼″. (Published in 1973 by Portal Publications, Sausalito, Calif. "17″ by 30″ with margins.") A nude girl swings in space in the lower left. Castles are in the clouds beyond, and the branches of a tree intrude from the upper right corner. (There is reported to be a reverse printing of this scene. Unverified.)

The Fly-Away Horse. p. 144. Book size 6¾″ by 5″. Print size 15″ by 11″. Two large, comic figures in purple frame a small boy who is mounted on a white horse.

The Little Peach. p. 96. Book size 7¼″ by 5″. Print size 15″ by 11″. A boy and a girl sit under a cloudy sky, facing each other, with their chins in their hands.

Seein' Things. p. 192. Book size 7⅛″ by 5″. Print size 15″ by

11". A small boy sits up in bed in the dark, "seein' things."
Shuffle-Shoon and Amber Locks. p. 170. Book size 7" by 5".
Print size 15" by 11". An aged man and a little boy are seated
outdoors, surrounded by children's blocks.
The Sugar Plum Tree. p. 28. Book size 7⅜" by 5". Print size
15½" by 10½". Five small children stand beneath tall trees, with
castles and a full moon in the background.
With Trumpet and Drum. p. 2. Book size 7⅜" by 5". Print size
15¼" by 10¼". A group of children "play parade" with large
flags.
Wynken, Blynken and Nod. p. 62. Book size 7¼" by 5". Print
size 15½" by 10¼". Three children set sail in a wooden-shoe sail-
boat beneath a rising full moon.

The Poster, An Illustrated History From 1860. Harold F. Hutchi-
son. New York: The Viking Press, Inc., 1968, p. 42. Black and white
illustration of the *Century Magazine* Midsummer Holiday Num-
ber, August, 1897.

Posters. Bevis Hillier. New York: Stein and Day, 1969, pp. 160-63.
Black and white illustration of *Century Magazine* Midsummer
Holiday Number, August, 1897; color illustration of *Scribner's*
Fiction Number, August, poster. Short text on Parrish.

*Posters. A Critical Study of the Development of Poster Design
In Continental Europe, England and America.* Charles Matlack
Price. New York: George W. Bricka, 1913. Five illus., tipped:
 p. 181, *Century* Midsummer Holiday Number, August, 1897,
color.
 p. 183, *Scribner's* Fiction Number, August, black and white.
 p. 353, *Collier's* cover, September 24, 1910, **The Idiot (#1)**,
color.
 p. 355, *Collier's* cover, June 26, 1909, black and white.
 p. 357, *Collier's* cover, July 1, 1905, black and white.

Posters In Miniature. New York: R. H. Russell, 1897. London:
John Lane, 1897. This volume is unpaged. The illustrations are
shown in alphabetical order by the names of the illustrators. Two
Parrish posters in black and white: *Century Magazine* Mid-
summer Holiday Number, August, 1897, poster; and the Colum-
bia bicycle poster.

P's and Q's, A Book On The Art of Letter Arrangement. Sallie B. Tannahill. Garden City: Doubleday, Page & Co., 1927. On page 53 is an example of Parrish's signature.

Remember When. Allen Churchill. New York: Golden Press, Inc., 1967, p. 165. Color illustration of *Life Magazine* cover for March 29, 1923, **Morning**.

Romantic America. Robert Haven Schauffler. New York: The Century Co., 1913. Frontispiece in color, **The Grand Canyon of the Colorado**.

The Ruby Story Book. Penrhyn W. Coussens. New York: Duffield & Co., 1921. Frontispiece in color, **Courage**. A large giant holds a small youth on the palm of his hand. (See also *Collier's Magazine* cover, July 30, 1910.)

The Sapphire Story Book. Penrhyn W. Coussens. Publishing data unavailable. Frontispiece in color. Description unavailable.

The Song of Hiawatha. Henry Wadsworth Longfellow. Boston: Houghton Mifflin Company, 1912. Paste-on cover in color depicts an Indian youth standing on a rock in a river, holding a drawn bow and arrow. Mists are below him, and above and beyond him are high, golden mountains. (See also *Collier's Magazine* cover, Oct. 14, 1905.)

Stories of Chivalry Retold From St. Nicholas Magazine. New York: The Century Company, 1913. Reported to have black and white frontispiece, description unavailable. Unverified.

Thirty Favorite Paintings. New York: P. F. Collier & Son, 1908, n.p. One color illustration, 10½″ by 14½″, **Pierrot's Serenade**.

This Fabulous Century—1910-1920. Time-Life Books. New York: Time, Inc., 1969, p. 109. Color illustration of *Collier's Magazine* cover for Sept. 30, 1911, **Arithmetic**.

The Topaz Story Book. Ada M. and Eleanor L. Skinner. New York: Duffield & Co., 1917. Frontispiece in color, title unknown, of a father and son bringing home the groceries through a winter

landscape. (See also *Collier's Magazine* cover, Nov. 17, 1906.)

Troubadour Tales. Evaleen Stein. New York: Bobbs-Merrill Co., 1903. Boston: L. C. Page & Co., 1929. Color frontispiece, **A Journey Through Sunny Provence** (also titled **The Page of Count Reynaurd**). An eighteenth-century nobleman and his page ride their horses side by side. The foliage of a large tree, and a castled town, are behind them.

The Turquoise Cup and The Desert. Arthur Cosslett Smith. New York: Charles Scribner's Sons, 1903, 1910.
Frontispiece in color, "The Cardinal Archbishop Sat on His Shaded Balcony."
The 1903 edition of the book does not contain the color illustration of an Arab, from "The Desert," which appears as the frontispiece in *Scribner's Magazine*, Dec., 1902; nor the black and white illustration for "The Turquoise Cup," "Lady Nora and the Cardinal in St. Marks," which appears in *Scribner's Magazine*, Dec. 1901, p. 689.
Information on illustrations in the 1910 edition unavailable.

The Turquoise Story Book. Ada M. and Eleanor L. Skinner. Publishing data unavailable. Frontispiece in color. Description unavailable.

Water Colour Rendering Suggestions. Maxfield Parrish and Jules Guerin. Cleveland, Ohio: J. H. Jansen, n.d. Student's Edition. Contains thirty plates, two only by Parrish: **The Pool at Villa D'Este**, and **I'm Sick of Being a Princess**.

————. Maxfield Parrish and Jules Guerin. Cleveland, Ohio: J. H. Jansen, 1917. Seven plates by Parrish, in order of appearance in the book: **Isola Bella, Lake Maggiore; The Little Princess; The Pool, Villa D'Este; Seven Green Pools at Cintra; The Theatre, Villa Gori; Villa D'Este; Villa Gori, Siena.**

Whist Reference Book. Editor(s) and publishing data unavailable. Black and white title page portrays playing-card characters of a king and a queen on their thrones, with opposing attendants displaying a large book before them. (See *Century Magazine*, July, 1912, "A Master of Make-Believe," by Christian Brinton.)

The Wind In The Willows. Rumors persist that there is an edition of this book having an embossed cover design by Parrish. Unverified.

The Wonder Book and Tanglewood Tales. Nathaniel Hawthorne. New York: Duffield & Co., 1910. Ten vertical illustrations and paste-on cover in color. All of the illustrations have been published as larger-than-book-size prints.

The cover print is 7¾" by 6¼", **Circe's Palace**, which also appears in the book, p. 258.

The Argonauts in Quest for the Golden Fleece. p. 340. Book size 6½" by 5". Print size 11½" by 9¼". A small sailing vessel, in deep blue waters, is silhouetted against high mountains. Two shafts of sunlight come from the right.

Atlas. p. 88. Book size 6¼" by 5". Print size 11½" by 9¼". A towering figure bears the clouds on his shoulders.

Bellerphon by the Fountain of Pirene. p. 144. Book size 6¼" by 5". Print size 11½" by 9¼". A small, nude male figure sits on the rocks above a pool. A large tree, small buildings, and mountains, are above him.

Cadmus. p. 226. Book size 6⅜" by 5". Print size 11½" by 9¼". A bold male figure with dark, swirling draperies, is silhouetted against the sky. He carries a red bowl and swings his arm in the sowing gesture.

Circe's Palace. p. 258. (This is also the cover illustration.) Book size 6⅜" by 5". Print size 11½" by 9¼". A woman, gowned in purple, leans over a large silver vat. A sailing vessel approaches in the background.

The Fountain of Pirene. p. 162. Book size 6⅜" by 5". Print size 11½" by 9¼". Two nude male figures relax by a stream in shadowed woods. Shafts of sunlight shine down from the right.

Jason and His Teacher. (Also titled **The Centaur**.) p. 322. Book size 6⅜" by 5". Print size 11½" by 9¼". Two youths and a centaur stand together, armed with bows and arrows.

Jason and the Talking Oak. Frontispiece. Book size 6⅜" by 5". Print size 11½" by 9¼". A male figure wearing a cape, stands on a boulder beneath a spreading oak tree.

Pandora. p. 64. Book size 6¼" by 5". Print size 11½" by 9¼". Framed by the circular window behind her, Pandora sits on the floor beside a large wooden chest.

Proserpina. (Also titled **Sea Nymphs.**) p. 288. Book size 6¼″ by 5″. Print size 11″ by 9″. A girl standing against a boulder looks down at three mermaids in the surf at her feet.

You and Your Work. Robert Kemp. Troy, New York: Radiant Energy Press, 1944, pp. 20, 21. Color frontispiece, **Tranquility.** Text on Parrish.

WHAT THE WORLD IS DOING

Headpiece by Parrish for *Collier's* magazine June 3, 1905. The original was twice this size

ILLUSTRATIONS
IN PERIODICALS

AMERICAN HERITAGE

1961. Dec. "An Illustrated Washington Irving Miscellany," pp. 41-55. Black and white illustration, "They introduced among them . . .", from *Knickerbocker's History of New York*.

1962. Feb. Breitenbach, Edgar. "The Poster Craze," pp. 26-31. Color illustration of *Scribner's* Fiction Number, August, poster.

1970. Dec. Glueck, Grace. "A Taste of Parrish," pp. 16-27. Fourteen color illustrations. From *The Knave of Hearts:* the title page (which is used for a title page in this article), Two Cooks With Spoons, and Lobsters With Cook.

Life Magazine cover for August 30, 1923, The Chef Samples the Pot (stated to have been a *Life Magazine* cover in 1925); *Life Magazine* cover for January 31, 1924, **A Good Mixer**.

Two Edison-Mazda prints; **Two Girls by a Mountain Torrent**, and **The Venetian Lamplighter**.

Three *Collier's Magazine* covers; **Arithmetic, The Idiot (#1)**, and **The Tourist**.

Cadmus, from *The Wonder Book*; **Falls by Moonlight**; **The Land of Make-Believe**; and **Old King Cole** (St. Regis). Five black and white portraits of the artist.

AMERICAN MAGAZINE

1918. Sept. Djer-Kiss Cosmetics color advertisement on back cover. Description unavailable.

1921. July. Hires Root Beer sepia advertisement, p. 71. Three elfin figures stand around a steaming kettle.

1930. May. "Twilight," p. 31. Two color illustrations: **Twilight (#4)**, a very dark composition depicting a small house beneath large trees, silhouetted against the sunset's afterglow; and a Valentine the artist created for his daughter, which shows a medieval page, in purple cap, white collar and figured skirt, holding a red heart upright in a green cloth, with "Be My Valentine" appearing on a scroll at his feet.

THE AMERICAN MAGAZINE OF ART

1918. Jan. Adams, Adeline. "The Art of Maxfield Parrish," pp. 84-101. Sixteen black and white illustrations: **The Landing of the Brazen Boatman**, and **The Search for the Singing Tree**, from *The Arabian Nights*.

The **Dinkey Bird**, and **Wynken, Blynken and Nod**, from *Poems of Childhood*.

Collier's Magazine covers for Jan. 5, 1907, The New Year; Sept. 24, 1910, **The Idiot (#1)**; and Nov. 1, 1919, **The Toy Show**.

Villa Campi, from *Italian Villas and Their Gardens*.

Belles Lettres (a mailbox design), **Quod Erat Demonstrandum, Sing a Song of Sixpence**.

Castle of Indolence, which is one of the **Florentine Fête Murals**.

A Fisk Tires advertisement, **The Modern Magic Shoes**.

Cover design for Scribner's Christmas *Book Buyer*, and a costume design for a gnome.

Portrait of Parrish by Kenyon Cox.

THE AMERICAN MONTHLY REVIEW OF REVIEWS

1900. Dec. Knaufft, Ernst. "Art In the Holiday Books," p. 750. Small black and white illustration, **Father Knickerbocker**, from *Knickerbocker's History of New York*. Paragraph on Parrish.

1918. Feb. Color advertisement for Edison-Mazda, **And Night is Fled**, n.p.

ANTIQUES

1936. Oct. Announcement of coming exhibition at The Old Print Shop, New York, p. 172. Small black and white illustration, **Daybreak**.

1966. Jan. Announcement of exhibition at The George Walter Vincent Smith Art Museum, Springfield, Massachusetts, p. 36. Small black and white illustration, **The Errant Pan**.

ARCHITECTURAL RECORD

1907. Jan. Croly, Herbert D. "The Knickerbocker Hotel, A Novelty In Decoration," pp. 2-3. Black and white illustration, **Old King Cole** (St. Regis); photograph of the mural in place above the bar.

ARCHITECTURE LEAGUE OF NEW YORK—YEARBOOK

1914. Black and white prints of two of the **Florentine Fête Murals**, verso of title page. One is **The Garden of Opportunity (#1)**.
 The second print shows a young couple, strolling east, the man looking back over his shoulder. Behind them, young people lounge above the short flight of steps, between two urns. A colorful sky and rugged mountains can be seen through the foliage above them. Title unknown.

1917. Three black and white illustrations, volume unpaged. Two of the illustrations are of the decoration in the studio of Mrs. Harry Payne Whitney, in Wheatley Hills, Long Island. The scene is reminiscent of the **Florentine Fête Murals** in that it shows young people in medieval costume, strolling in front of a low wall. On the pedestals at each side of an opening in the wall are large urns. Foliage and flowers fill out the background.
 The third illustration is **Castle of Indolence**, one of the **Florentine Fête Murals**.

ART IN AMERICA

1957. Summer. Jones, E. P. "The Lively Wall-Murals of Manhattan," pp. 24-25. Black and white illustration, **Old King Cole** (St. Regis).

1965. April. p. 151, small black and white illustration, **Land of Make-Believe.** A young couple stand between tall pillars in a rose garden. They are flanked by large urns. Above and behind them on the right are branches of a tall tree, and in the distance are sunlit cliffs.

1969. June. p. 76, small black and white illustration, **The Young Gleaner.** A girl has wrapped a sheaf of wheat in the corner of her apron, and holds it in the crook of her right arm. She carries a sickle in her left hand. Her head is outlined against the sun as she stands before a landscape of trees and castles.

THE ART INTERCHANGE

1896. June. "The Poster of Today," pp. 138-40. Mention of Parrish winning First Prize for the Pope Manufacturing Company poster contest, and Second Prize for the *Century Magazine* poster contest, with black and white illustrations of each poster.

THE ART JOURNAL

1903. June. "The New Gallery Exhibition of 1903," pp. 182-87. Black and white illustration, **The Reluctant Dragon**, from *The Golden Age.*

1965-66. Ludwig, Coy. "From Parlor Print to Museum: The Art of Maxfield Parrish," pp. 143-46. Four black and white illustrations: "Blacksmiths . . .", from *Knickerbocker's History of New York*; **The Garden of Allah; The Idiot (#1)**; and "Once more the damsels rescued . . .", from *The Golden Age.*

ART NEWS

1969. Sept. Koethe, John. "Boston Is Here, Now," pp. 31-33. Black and white illustration, **I'm Sick of Being a Princess.**

THE ARTIST

1898. unk. S. C. de S. "Some American Posters," pp. 16, 21. Two black and white illustrations: *Century Magazine* Midsummer Holiday Number, August 1897, poster; and *Scribner's* Fiction Number, August, poster.

ARTS AND DECORATION

1923. Oct. McCann, E. Armitage. "A Significant Showing of Industrial Art," p. 33. Black and white illustration, **Daybreak.**

THE ATLANTIC MONTHLY

1919. July. Reported to be black and white Fisk Tires advertisement, p. unk. Unverified.

1921. June. p. 8, color advertisement for Hires Root Beer, three elfin figures stand around a steaming kettle.

1925. Dec. p. 32, small black and white **Potato Peelers**, from *The Knave of Hearts.*

THE BOOK BUYER (Scribner)

1897. Christmas. Cover design in color, a young man sits reading amid a pile of books.

1898. April. Carrington, James B. "The Work of Maxfield Parrish," pp. 220-24. Five black and white illustrations: "The hill on one side descended to the water . . .", and "A very fascinating background it was . . .", both from *Scribner's Magazine*, Aug., 1897; **The Man in the Moon**, from *Mother Goose In Prose*; **Mother Goose** (description unknown); and **Old King Cole** (Mask and Wig).

1898. Dec. Black and white cover design of a robed man reading amid a pile of books.

1899. April. Black and white cover design of a youth sitting on a stone wall, reading. A town is seen in the background.

———. **Dec.** Black and white cover design of a youth sitting on a stone wall, leaning on a pile of books as he reads.

THE BOOKMAN

1899. Feb. Hoeber, Arthur. "A Century of American Illustration," pp. 540-48. Black and white illustration, **The Three Wise Men of Gotham**, from *Mother Goose In Prose*.

1900. Sept. p. 16, black and white illustration, **Saint Nicholas**, from *Knickerbocker's History of New York*. Mention of Parrish as the artist.

BOOKNEWS

1895. October, November and December all carry the same cover in black and white, a robed woman who stands holding a large open book.

1896. January and February, same as previous entry.

1896. March through September issues all carry the same cover, in monotone green, highlighted with black and red. A robed woman, bending over a lectern, is looking at a book; overall pattern of leaves is in the background.

1897. March. Cover, same as previous entry, except that the highlights are black and green.

———. **April.** Cover, same as previous entry, except that the highlights are black and blue.

———. **June.** Cover, depicting a profile woman with hand on hip, between two pillars, reading a book. Castles and trees are in the background. Black and white, with a pale blue sky.

BRADLEY, HIS BOOK

1896. Nov. "Maxfield Parrish," pp. 13-15. The article title is a copy of Parrish's own signature. Four black and white designs: A comic figure holds the first letter of the article, which is an H.

Poster for, "Philadelphia Horse Show Association, 5th Annual Open-Air Exhibition, Wissahickon Heights, 1896. May 26-27-28-29-30. Price-25," shows a comical gallant in plumed hat, astride a caparisoned horse, holding a staff from which yards of banner unfurl. The information about the show appears on the banner.

Program cover for the Mask and Wig Club production, *No Gentleman of France*, depicts a man on a horse. The man appears to be a caricature of Napoleon.

The tailpiece is of two comic policemen, with their nightsticks, holding between them a sign, "The End."

Frontispiece in the magazine, The Clown, is in pale yellow and green, and is the central figure from Clowns, which was Parrish's first sale. (See *Survey*, Aug., 1929.)

BRUSH AND PENCIL

1898. Jan. "Art Features of the New Books," pp. 126-28. Three black and white illustrations: **The Man in the Moon; Jack Horner;** and **The Wond'rous Wise Man**; all from *Mother Goose In Prose*.

CALIFORNIA LIBRARIAN

1973. April. Maxim, David. "Maxfield Parrish: Illustrator of Paradox," pp. 16-23. Magazine bears cover illustration in monotone green, "On to the garden wall, . . .", from *The Golden Age*.

Article is illustrated with four black and white illustrations: *Century Magazine* Midsummer Holiday Number, August; **Mutabile Semper**, from *Dream Days*; small "On to the garden wall, . . ."; and **Queen Gulnare**, from *The Arabian Nights*.

Article is also illustrated with three monotone green illustrations from *Dream Days*: **Its Walls Were as of Jasper (#1)**; **The Reluctant Dragon**; and the Title Page.

THE CENTURY MAGAZINE

1898. Dec. Clarke, Ednah Proctor. "Christmas Eve." Sepia double frontispiece illustrates the poem. Berceuse, portrays a draped woman with a halo, sitting within a formal archway. She appears to be holding a baby. A large tree and a small village are behind her.

The second page depicts two kneeling shepherds with three sheep, framed within a formal archway above the poem.

1899. Dec. Wildman, Marian. "A Hill Prayer," pp. 221-23. Black and white poem illustration, Inspiration, portrays a youth standing in a forest, with eyes raised. There are also two page border designs.

1900. July. Tynan, Annie E. "The Story of Ann Powel," pp. 335-40. Black and white illustration of a Quaker girl standing in a doorway.

———. Dec. Black and white Fisk Tires advertisement, p. 133, **The Magic Circle.** A bearded man holding a wand and dressed in checked garments, is seated cross-legged within the circle of a tire.

1901. Jan. McNeal, Mildred I. "Storm Song of the Norsemen," pp. 342-45. Black and white poem illustration of a figure at the steering oar of a boat, with his head obscured by fog. There are also three page border designs.

———. Dec. Milton, John. "L'Allegro," pp. 161-69. Four color illustrations: "And the milkmaid . . .", shows a milkmaid with two pails, standing in the shadow of surrounding trees. Beyond her are sunlit woods, a castle and a cloudy sky.

"Straight mine eye . . .", portrays two sheep grazing in the shadowed right foreground. Through the trees beyond them a river winds at the base of hills under a windswept sky.

". . . caught new pleasures . . .", depicts three shepherds resting on a green hillside. Part of their flock is in sunshine, part in shadow. Beyond them a mass of dark trees is outlined against the clouds.

THE CENTURY MAGAZINE

"Such sights as youthful poets dream . . .", shows a young man in robes, leaning against boulders by a little stream, in the shadowed woods. Amid the mists and sunlit crags above him, a castle clings to the mountainside.

———. **Dec.** Allen, Charles D. "The Appeal of the Bookplate— Antiquarian and Artistic," pp. 240-46. Black and white bookplate portraying two men seated in carved chairs, facing each other in discussion, and the wording: **John Cox—His Book**.

1902. May. Baker, Ray Stannard. "The Great Southwest," pp. 1-15. Two color illustrations (no titles given): A canal winds through a pasture, with trees on the left and cattle in the distance.

A purple-blue mountain is outlined in the distance against a yellow skyline. A bare shrub is on the right and a colorful, cloudy sky is over all.

Four black and white illustrations: **Two Cowboys**, depicts two cowboys with their horses, standing by a reflecting pond.

The Grand Canyon of the Colorado, shows the river at the base of towering, rocky mountains.

The Mexican, a Mexican with his rifle is outlined against the sun as he leads his packed burro through the sand.

Pueblo Dwellers, shows three Indians standing in the shadowed foreground, with their sunlit, cliff-top pueblos in the background.

———. **June.** Baker, Ray Stannard. "The Great Southwest," pp. 213-25. Five black and white illustrations:

The Bed of a Typical Southwest River, two small horsemen ride in the flat, dry riverbed, between massive stone cliffs, toward scattered rocks in the foreground.

Formal Growth in the Desert, three little burros are in the foreground, with sagebrush, mountains and cumulus clouds beyond them.

A Gold-Mine in the Desert, small mine buildings lie in the shadows at the foot of a sunlit mountain range.

Night in the Desert, two men sit in the dark beside a small fire at the foot of massive boulders, with cactus in the foreground and stars overhead.

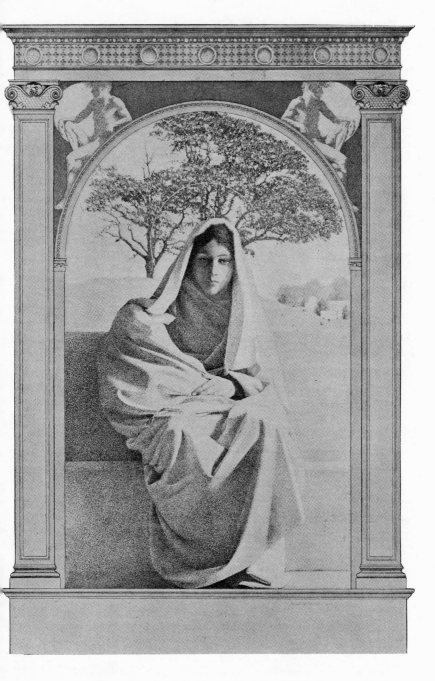

Berceuse, an illustration for "Christmas Eve" by Ednah Proctor Clarke
in the *Century*, December 1898

Inspiration, an illustration for "A Hill Prayer" by Marian Wildman in the
Century, December, 1899

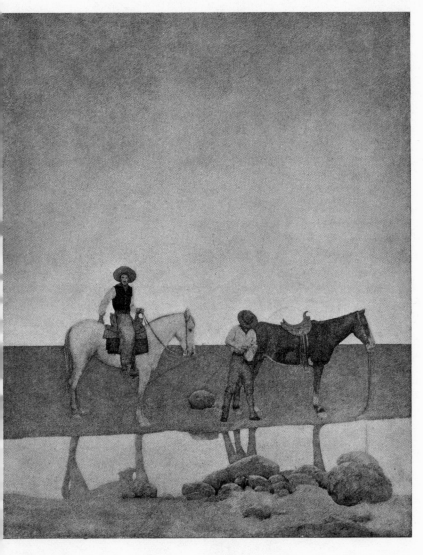

Cowboys, one of the illustrations for Ray Stannard Baker's "The Great Southwest" which appeared in the *Century*, May 1902

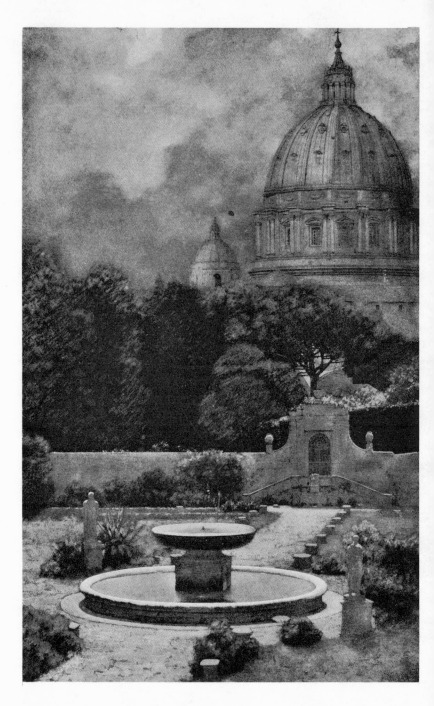

The Dome of St. Peter's from the Vatican Gardens from Edith Wharton's "Italian Villas and their Gardens" published in the *Century*, Feb. 1904

THE CENTURY MAGAZINE

Sunrise in the Desert, the sun appears from behind distant mountains, showing boulders and cactus in the foreground.

_____. **July.** Baker, Ray Stannard. "The Great Southwest," pp. 361-73. Four black and white illustrations: **The Desert with Water**, cattle graze in the dappled shade of trees in a pasture.

The Desert Without Water, two cowboys on their horses, and a low range of mountains, are the only objects to break the expanse of sand and sky.

Irrigating-Canal in the Salt River Valley, the canal at dusk is flanked by a bushy tree and a distant mountain, with a sickle moon in the sky.

Water Let in on a Field of Alfalfa, puddles of water in a field reflect the white summer clouds; trees and a small barn are at the far end of the field.

_____. **July.** "Maxfield Parrish's Western Pictures," p. 486. An editorial on "The Great Southwest" illustrations.

_____. **Aug.** Baker, Ray Stannard. "The Great Southwest," pp. 535-44. Four black and white illustrations: **Bill Sachs**, portrait bust of a bearded man with his hat on, is profiled against a desert background.

"The Cactus Came . . .", a cactus bed is outlined against the desert, the mountains and the sky.

In the Track of the Flood, piles of boulders surround a patch of sand.

The Sign of a Thirsty Land, an animal skeleton lies in a dry, rocky creek bed at the base of bare mountains.

_____. **Nov.** "The Southwest In Color," pp. 160-61. Seven color illustrations from "The Great Southwest," pp. 1-8; **Bill Sachs, The Desert with Water, The Desert Without Water, Formal Growth in the Desert, The Grand Canyon of the Colorado, Pueblo Dwellers,** and **Water Let in on a Field of Alfalfa.**

1903. Nov. Wharton, Edith. "Italian Villas and Their Gardens; Florentine Villas," pp. 21-33. Four color illustrations: **Boboli,**

THE CENTURY MAGAZINE

Gamberaia, and the magazine frontispiece which is **Villa Campi**. The fourth color illustration is the title page for the article, and shows a distant landscape, beneath decorative scrolls and beyond a balustrade; with the title beneath it flanked by matching urns. Black and white illustration, **Corsini**.

——. **Dec.** Wharton, Edith. "Italian Villas and Their Gardens; Sienese Villas," pp. 162-64. Three color illustrations; **Theatre at Villa Gori, Vicobello**, and **Villa Gori**.

1904. Feb. Wharton, Edith. "Roman Villas," pp. 562-72. Two color illustrations; **Villa Chigi** and **Villa Medici**. Three black and white illustrations; headpiece, **The Dome of St. Peter's**, and **Villa Pia**.

——. **April.** Wharton, Edith. "Villas Near Rome," pp. 860-74. Two color illustrations; **The Pool at D'Este**, and **Villa D'Este**. Two black and white illustrations, **The Reservoir at Falconieri**, and **Torlonia** (also titled **The Cascade, Villa Torlonia**.)

——. **Aug.** Wharton, Edith. "Lombard Villas," pp. 541-54. Four color illustrations; **Cicogna, In the Gardens of Isola Bella, Isola Bella**, and **Pliniana**.

——. **Oct.** Wharton, Edith. "Italian Villas and Their Gardens; Villas of Venetia, Genoese Villas," pp. 884-902. Color illustration, **Villa Scassi**. Five black and white illustrations; **A Garden-Niche, Gateway of the Botanic Gardens at Padua**, title page, **Val San Zibio, View at San Zibio**.

——. **Nov.** Keats, John. "To Autumn," pp. 86-87. Two color illustrations: A large, lavender cumulus cloud almost fills the blue sky above a peaceful summer countryside, which consists of rolling hills, trees, a river, and distant mountains. A larger tree on the left stands above a sunny spot on the hillside.

The second illustration is of a figure with a sickle, standing on a hill, outlined against a deep blue sky. (No formal titles known.)

THE CENTURY MAGAZINE

_____. **Dec.** Patch, Kate Whiting. "The Princess and The Boy," p. 263. Color illustration, **I'm Sick of Being a Princess.**

1905. March. Morris, Harrison S. "Philadelphia's Contribution to American Art," pp. 714-33. Black and white illustration, **A Journey Through Sunny Provence**, from *Troubadour Tales.*

_____. **Oct.** Frontispiece in color, **The Sandman.** In the shadowy foreground the Sandman bends under the weight of his loaded sack. He wears a cavalier's hat and a long, dark cape. In the right background is a big tree, and in the left background a castled town silhouetted against the full yellow moon reflects the last light of day.

1910. Aug. Wilkinson, Florence. "Seven Green Pools At Cintra." Frontispiece poem illustration in color. In darkening twilight woods a young woman fastens roses in her hair while a young man stands nearby.

_____. **Nov.** p. 144, black and white illustration of a figure at the steering oar of a boat, with his head obscured by fog, from "Storm Song of the Norsemen." (See *Century Magazine*, Jan. 1901.)

1911. Feb. Frontispiece in color, **Sing a Song of Sixpence.**

_____. **April.** p. 897, illustration in color, **Quod Erat Demonstrandum** (Proving It By The Book). Two colonial men sit at a tavern table, one with a book. Pewter mugs are before them, and a dog sits on the floor beside them. The original painting was done for The Meeting House Club, in New York City.

1912. April. Frontispiece in color, the sketch for the mural in the James J. Storrow residence, Lincoln, Massachusetts. Beneath an arched top, a nude male figure sits on foreground rocks. Three large tree trunks, distant water and an island castle, complete the scene.

THE CENTURY MAGAZINE

———. **July**. Brinton, Christian. "A Master of Make-Believe," pp. 340-52. Fifteen black and white illustrations: Title page for *Whist Reference Book*.

Bookplate of **Ellen Biddle Shipman**, consisting of two comic soldiers, with blunderbusses, standing on a banner which states, "Ellen—Her Book," and supporting between them a hoop which encircles the words, "Be Good."

Pierrot, a paper cut-out.

Humpty Dumpty (*Mother Goose*).

A Journey Through Sunny Provence, from *Troubadour Tales*.

Tom, the Piper's Son, from *Mother Goose In Prose*.

Paper cut-outs of two girlish figures.

Paper cut-out, profile of a girl's head.

An envelope design of a comical figure in a top hat, holding a banner for the postage stamp.

Paper cut-outs, The Militiaman, and Shabby Genteel.

Old King Cole (Mask & Wig) shows the King sitting in profile on the right, with a pet stork beside him; three fiddlers face him in the center; and a chef with pipe and bowl is on the left.

A French cook on a fanciful menu.

Paper cut-out, a Roman soldier.

Decoration on the outside of an envelope sent by mail from Parrish to Austin M. Purves, Jr., which shows a comic militiaman, in full uniform, striding along with a sign under his arm which carries the name and address.

———. **Aug.** pp. 554-57. Six **Florentine Fête Murals** illustrated on four pages, no article. Three titles known; **Buds Below the Roses, Call to Joy**, and **Shower of Fragrance**.

1915. Dec. p. 161, color illustration, **Pipe Night at The Players**. Two jolly men are seated at a table enjoying their pipes. The original painting was done for the Players Club, in New York City.

1917. Aug. Midsummer Fiction Number cover in color, of a nude, hugging her knees, seated on the grass in front of trees which are silhouetted against a yellow sky. This is the Second Prize winner for the *Century Magazine* poster contest in 1897, entitled "Midsummer Holiday Number, August."

1918. Dec. Community Plate Silverware color advertisement, two pages hold a box of silverware between them.

1921. June. Hires Root Beer color advertisement, in the front of the magazine, three elfin figures stand around a steaming kettle.

———. **July.** Hires Root Beer color advertisement, in the front of the magazine, consists of one of the elfin figures from the group around the steaming kettle. (See previous entry.)

CHICAGO TRIBUNE

1936. Feb. 2. Bennett, James O'Donnell. "Vanderpoel Art Gallery's Head Has New Canvas," p. 11. Black and white photograph of **Entrance of the King**, from *The Knave of Hearts*. Portrait of Parrish.

CHRISTIAN HERALD

1919. March. Ferry's Seeds color advertisement, **Peter, Peter, Pumpkin Eater**, 8″ by 7½″. Peter sits in a green chair with his pipe in his hand. His wife sits on a pumpkin beside him, sewing. This is one of four advertisements painted by Parrish for Ferry's Seeds.

COLLECTOR'S WORLD

1971. May-June. Rodger, William. "About Books," p. 24. **John Cox** bookplate adapted for the title of the article.

COLLIER'S MAGAZINE

From 1904 through several years following, *Collier's Magazine* used various column heading and tailpiece designs created by Parrish. These were usually in black and white, for headings titled, "What the World Is Doing," "Collier's the National Weekly," "Editorial Bulletin," "Plays of the Month," "The Sportsmen's Viewpoint," "Comments on Congress," and others. These designs were used over and over, and no attempt has been made to list all their sources in the *Guide*. Some of these designs are initialled by the artist, some are not.

COLLIER'S MAGAZINE

There will be several references to a cover design of two robed figures facing each other over the Table of Contents. This design was used many times, each time with a different color combination. It was also used as end papers and page decorations in other Collier's publications.

Many issues of the magazine bear titles designating particular issues, such as Annual Review Number, Independence Number, Thanksgiving, Christmas, etc. These titles are listed in the *Guide* to assist in identification. Formal titles of Parrish works will be printed in bold face.

unk. Dec. unk. Black and white column heading of nine chefs, each with a plum pudding; one letter on each pudding adds up to "Christmas." Unverified.

1904. Oct. 29. Black and white column heading for "Readings and Reflections," p. 21. This design consists of a horizontal landscape, with a decorative banner and a mask above it, and a partial nude posed at either end.

_____. Dec. 3. Cover in color, **Three Shepherds** look to the sky. A small fire burns at their feet; tree branches intrude in the upper right corner. From *The Golden Treasury*.

1905. Jan. 7. Annual Review Number. Cover in black, white and gold, of Father Time winding a great clock.

_____. Feb. 11. Cover in color, two robed figures face each other over Table of Contents.

_____. Mar. 4. Cover in color, robed figures form a frame around a photograph of President Theodore Roosevelt.

_____. Apr. 15. Cover in color, **Easter**, from *The Golden Treasury*.

_____. May 6. Cover in color, **Spring**, from *The Golden Treasury*.

_____. May 20. Cover in color, two robed figures face each other over Table of Contents.

COLLIER'S MAGAZINE

———. **June 3.** Same as previous entry.

———. **July 1.** Independence Number. Cover in color, a Colonial lad shows Declaration of Independence to a surprised British King.

———. **July 22.** Cover in color, **Summer**, from *The Golden Treasury.*

———. **Aug. 5.** Cover in color, two robed figures face each other over Table of Contents.

———. **Sept. 23.** Cover in color, **Harvest**, from *The Golden Treasury.*

———. **Oct. 14.** Cover in color, an Indian youth stands on a rock in a river, with drawn bow and arrow. Mists are below him, and above and beyond him are high, golden mountains. (See *The Song of Hiawatha.*)

———. **Oct. 28.** Cover in color, **Autumn**, from *The Golden Treasury.*

———. **Nov. 4.** Cover in color, two robed figures face each other over Table of Contents.

———. **Nov. 18.** Thanksgiving. Cover in color, **The Tramp's Dinner.** A tramp with his sandwich, is seated by a small fire.

———. **Dec. 2.** Cover in color, two robed figures face each other over Table of Contents.

———. **Dec. 16.** Cover in color, **The Boar's Head.** Two men seated at a table prepare to enjoy a Christmas feast of roast boar's head.

1906. Jan. 6. The New Year. Cover in color, a barefoot boy in an oversize coat stands beside luggage embossed, "1906."

———. **Feb. 10.** Lincoln's Birthday Number. Cover in color, of a young man seated on a rock. (Possible representation of Lincoln.)

———. **Mar. 10.** Cover in color, **Winter.** A man in a dark overcoat stands beside an ox which is hitched to a stoneboat.

COLLIER'S MAGAZINE

——. **Apr. 7.** Frontispiece in color, **The Fisherman and the Genie**, from *The Arabian Nights*.

——. **Apr. 14.** Cover in color, two robed figures face each other over Table of Contents.

——. **May 19.** Cover in color, **Milking Time**. A farmer stands holding a milk pail.

——. **June 23.** Cover in color, **The Gardener** (*Collier's*).

——. **July 7.** Independence Number. Cover in color, a group of children are carrying American flags.

——. **July 21.** Cover in color, a young woman wearing green draperies, swings in a swing.

——. **Sept. 1.** Frontispiece in color, **Prince Codadad**, from *The Arabian Nights*.

——. **Oct. 13.** Frontispiece in color, **Prince Agib**, from *The Arabian Nights*.

——. **Oct. 27.** Editorial, p. 7, commenting on the recent Parrish frontispieces. Headpiece and tailpiece for the article by Parrish.

——. **Nov. 3.** Frontispiece in color, **Cassim**, from *The Arabian Nights*.

——. **Nov. 17.** Thanksgiving. Cover in color, a father and son bring home the groceries through a winter landscape.

——. **Dec. 1.** Frontispiece in color, **The Talking Bird**, from *The Arabian Nights*. (Also titled **The Search for the Singing Tree**.)

——. **Dec. 15.** Christmas Number. Frontispiece in color, a boy sits up in bed, examining his Christmas stocking.

COLLIER'S MAGAZINE

———. **Dec. 22.** Black and white advertisement, p. 25, for 1907 calendar, two small illustrations: **Summer**, from *The Golden Treasury*; and *Collier's Magazine* cover, January 7, 1905.

1907. Jan. 5. Cover in color, the Old Year shakes the hand of the little New Year, who holds an umbrella.

———. **Jan. unk.** Cover in color, two robed figures face each other over Table of Contents.

———. **Feb. 9.** Frontispiece in color, **Sinbad Plots Against the Giant**, from *The Arabian Nights*.

———. **Feb. 9.** Column heading for, "The Lincoln Farm Association." This lightly tinted design consists of a horizontal landscape, with a robed man seated in the center. The frame for the title is supported by nude male figures at either end.

———. **Mar. 16.** Frontispiece in color, **The City of Brass**, from *The Arabian Nights*.

———. **May 18.** Frontispiece in color, **The Young King of the Black Isles**, from *The Arabian Nights*.

———. **June 22.** Frontispiece in color, **Aladdin**, from *The Arabian Nights*.

———. **Aug. 3.** Frontispiece in color, **Gulnare of the Sea**, from *The Arabian Nights*.

———. **Sept. 7.** Frontispiece in color, **The Valley of Diamonds**, from *The Arabian Nights*.

———. **Nov. 9.** Frontispiece in color, **The Brazen Boatman**, from *The Arabian Nights*.

———. **Nov. 30.** Cover in color, **Oklahoma Comes In**. Two boys,

COLLIER'S MAGAZINE

dressed as an Indian and a cowboy, celebrate Oklahoma statehood.

———. **Dec. 28.** Advertisement, p. 21, for *The Arabian Nights* prints, small black and white **The Fisherman and the Genie**.

1908. Jan. 11. "From Maxfield Parrish, Windsor, Vermont," p. 19-a. This is a short article on the artist's whimsey in addressing mail. A black and white illustration shows a little expressman pushing a dolly with two packages on it. The top package reads, "Express Paid," the bottom package reads, "From Maxfield Parrish, Windsor, Vermont."

———. **Jan. 25.** Frontispiece in color, **Circe's Palace**, from *The Wonder Book*.

———. **May 16.** Frontispiece in color, **Atlas**, from *The Wonder Book*.

———. **June 6.** Vaudeville Number. Cover in color, a short comic, with a green umbrella, defies a tall comic who wears a checked suit.

———. **July 4.** Cover in color, a comic soldier with a large sword.

———. **July 4.** Editorial page heading, p. 7, black and white comic soldiers march toward one another, on either side of a scroll which carries the page heading.

———. **July 18.** Cover in color, **The Botanist**, a severe-looking professor examines a tiny plant.

———. **August 8.** Cover in color, **Pierrot's Serenade**, from *The Golden Treasury*.

———. **Sept. 12.** Cover in color, **School Days**, a small boy reading a book is completely surrounded with interlocking letters, MP among them.

———. **Oct. 31.** Frontispiece in color, **Cadmus**, from *The Wonder Book*.

COLLIER'S MAGAZINE

____. **Dec. 12.** "The Knight," a short poem, accompanied by a black and white illustration of a comic knight, riding on a rocking horse. p. unk.

____. **Dec. 26.** Cover in color, **The Balloon Man**, a man with a cluster of balloons holds his hat and fights the wind.

1909. Jan. 2. Cover in color, a comic sign painter paints the cover with this slogan: "- - - Plans for 1909."

____. **Mar. 20.** Dramatic Number. Cover in color, a small pierrot is enclosed in huge ram's horns and theatrical designs.

____. **Mar. 27.** "A Submarine Investigation," p. 7. Parrish created the design around the photograph of a small, beached submarine, with three goats beside it.

____. **Apr. 3.** Cover in color, **April Showers** (also titled **Peterkin**).

____. **Apr. 17.** Outdoor America. Cover in color, **The Lone Fisherman**, a solitary man fishes. The color scheme is orange and brown.

____. **Apr. 17.** "Be It Ever So Humble," p. 16. Parrish created the design around a photograph of a stooped man, walking up a path to a little house.

____. **Apr. 24.** Cover in color, **Old King Cole** (St. Regis), center section only, showing the King.

____. **May 1.** Cover in color, **The Artist**, an artist with his palette sits among the rocks; deep blue sky and water in the background.

____. **May 15.** Frontispiece in color, **Bellerphon by the Fountain of Pirene**, from *The Wonder Book*.

____. **May 29.** Cover in color, **Old King Cole** (St. Regis), right panel only, showing servants with the pipe and bowl.

COLLIER'S MAGAZINE

——. **June 26.** News-Stand Edition. Cover in color, a colorful pirate wields a huge sword.

——. **July 3.** Fourth of July. Cover in color, a young Rebel, seated on a bomb with a lit fuse, writes a letter to King George.

——. **July 3.** Advertisement, p. 3, for poster, small black and white **Toyland**, 75¢.

——. **July 3.** Advertisement, p. 2, for jig-saw puzzles of Parrish prints.

——. **July 10.** Cover in color, **The Tourist**, a man in a long overcoat, wearing glasses, stands with a guidebook in his hand.

——. **July 10.** Advertisement, inside front cover, for series of *The Arabian Nights* prints.

——. **July 24.** Advertising Number. Cover in color, two businessmen, one with an umbrella, and one with a paint pot and a brush.

——. **Oct. 16.** Frontispiece in color, **Pandora**, from *The Wonder Book*.

——. **Oct. 23.** It is believed that the four masks which decorate this cover may be the work of Parrish.

——. **Nov. 20.** Thanksgiving. Cover in color, a happy hunter wearing a green slouch hat, brown jacket, red gloves and rubber boots, carries his long rifle over his shoulder. From it hangs his game—the Thanksgiving bird.

——. **Dec. 11.** Cover in color, **The Wassail Bowl**.

1910. Jan. 8. Outdoor America. Cover in color, of the small figure of a girl on a sled, against a white background.

——. **Mar. 5.** Frontispiece in color, **The Argonauts in Quest of the Golden Fleece**, from *The Wonder Book*.

COLLIER'S MAGAZINE

———. **Apr. 23.** Frontispiece in color, **Proserpina** (also titled **Sea Nymphs**), from *The Wonder Book*.

———. **July 23.** Frontispiece in color, **Jason and his Teacher**, from *The Wonder Book*.

———. **July 30.** Cover in color, **Courage**.

———. **Sept. 3.** Cover in color, **Penmanship**, a small boy sits at a desk writing with pen and ink.

———. **Sept. 24.** Cover in color, **The Idiot (#1)**.

———. **Nov. 26.** Cover in color, two large red lobsters make a seat with their claws for a small chef. (See Lobsters With Cook, from *The Knave of Hearts*.)

———. **Dec. 10.** Frontispiece in color, **The Lantern Bearers**, from *The Golden Treasury*.

1911. Feb. 4. Cover in color, **The Prospector**, a prospector with a pick leans over to examine rock specimens.

———. **Mar. 11.** Cover in color, a soldier dressed in kilt and beaver hat, presents arms.

———. **Mar. 18.** Cover in color, two robed figures face each other over Table of Contents.

———. **Apr. 1.** Cover in color, **Man with Apple**—without the apple. A man dressed in a red and white checked robe appears to inspect an apple from the small tree behind him, but there is no apple in his hand. (It is thought this was a Parrish April Fool's joke.)

———. **Apr. 8.** Carmen, Bliss. "April," p. 12. A double frame encloses the poem in the upper half, and an illustration in pastels of a nude girl in a rose garden is in the lower half.

———. **Sept. 30.** Cover in color., **Arithmetic**, a small boy with a slate

COLLIER'S MAGAZINE

in his hand stands before a frowning, gesturing schoolmaster. The background is of mixed numerals.

1912. Nov. 2. Cover in color, **The Philosopher**, an old man in a red shirt, sits on a sawhorse smoking his pipe.

——. **Nov. 16.** Cover in color, two rows of identical comic soldiers, with their rifles, march across the page from east to west.

1913. May 10. Cover in color, a little fisherman wearing a bowler hat, sits atop a piling. His fishhook has caught the magazine price, 5¢.

——. **May 17.** Cover in color, a comic policeman, with his nightstick.

——. **Nov. 1.** Cover in color, comic soldiers hold the Table of Contents between them; one smiles and one frowns.

1929. Jan. 5. Cover in color, a bowing figure in red is enclosed in a full circle. Beneath his feet are the words, "The Best Is Yet To Come." (See, "The End," from *The Knave of Hearts.)*

——. **May 11.** Cover in color, **The Page**, from *The Knave of Hearts*.

——. **July 20.** Cover in color, two military attendants with golden trumpets, from *The Knave of Hearts*, with the Table of Contents between them.

——. **Nov. 30.** Cover in color, two cooks with outsize spoons, from *The Knave of Hearts*.

1936. Oct. 24. Cover in color, **Jack Frost**.

——. **Dec. 26.** Cover in color, two cooks with a large steaming copper kettle and a plum pudding.

COLUMBIA LIBRARY COLUMNS

1967. Nov. Faunce, Sarah. "Some Early Posters of Maxfield Parrish," pp. 27-33.

Five black and white illustrations: *Harper's Weekly* cover, Dec. 18, 1897; *Life* cover, March 3, 1904, Saint Patrick; *Scribner's* Christmas poster, 1897; *Scribner's* Fiction Number, August, 1897; and *Success* cover, Dec., 1901.

THE CONNOISSEUR

1967. Aug. Vose Galleries advertisement, p. 30, small black and white **Cadmus**, from *The Wonder Book*.

1968. Dec. Vose Galleries advertisement, p. 86, small black and white **Land of Make-Believe**.

1970. July. Vose Galleries advertisement, p. 82, small black and white **Early Morning, First Snow** (single title). Beyond a rocky mound and bare trees against the sky, on the left, part of a house can be seen. A tree in full leaf is behind the house. A sloping hillside and a distant mountain rise on the right.

COSMOPOLITAN

1901. Jan. Martin, C. S. "Knickerbocker Days," pp. 219-28. The nine black and white illustrations from *Knickerbocker's History of New York*.

COUNTRY LIFE

1918. May. Reported to be Fisk Tires color advertisement, **Fit for a King**, on the back cover. Two pages present a tire to the enthroned king, who peers at it over his glasses. Unverified.

1919. Aug. Fisk Tires color advertisement, p. 73, **Mother Goose** rides through the sky on a Fisk tire.

COUNTRY LIFE IN AMERICA

1917. Sept. Reported to be Fisk Tires color advertisement, **The Modern Magic Shoes.** Unverified.

1918. May. Reported to be Fisk Tires color advertisement, **Fit for a King.** Unverified.

1919. Aug. Fisk Tires color advertisement, p. 73, **Mother Goose.**

THE CRITIC

1896. Apr. 4. "Bicycle Posters," p. 243, mention of Parrish as First Prize Winner for the Pope Manufacturing Company poster contest. Black and white illustration of the poster, a girl in right profile, wearing a plaid dress, sits on a bicycle, only part of which is visible. Trees and clouds are in the background.

———. **May 16.** p. 357, prize-winning *Century Magazine* Midsummer Holiday Number poster in black and white.

1905. June. Saint Gaudens, Homer. "Maxfield Parrish," pp. 512-21. Seven black and white illustrations:
Century Magazine Midsummer Fiction Number poster.
Bookplate, a man holding a book sits beneath a tree with a castled town beyond him. Nude male figures flank the scene; panels above and below state: **Ethel Barrymore, Her Book.**
Bookplate for **Ellen Biddle Shipman.**
"You haven't been to Rome, have you?"; and "For them the orchard (a place elf-haunted, wonderful!)" from *The Golden Age.*
Dies Irae, from *Dream Days.*
A decorated postage stamp.
Photographs of the artist's home and machine shop.

THE DELINEATOR

1921. Aug. Djer-Kiss Cosmetics color advertisement, p. 36, of a girl in a swing, with bowers of roses over her head, and purple mountains in the distance.

1922. Mar. Jell-O color advertisement, p. 70, **The King and Queen**. Dressed in blue robes, the King and Queen sit on carved golden chairs, facing each other. Bowing between them, a servant in black and white robes offers a dish of Jell-O.

EVERYBODY'S

1901. Dec. Silberrad, V. L. "The Temptation of Ezekiel," p. 610. Black and white frontispiece story illustration of a holy man, contemplating in the desert wilderness.

THE FARMER'S WIFE

1922. Nov. Reported to be color Jell-O advertisement, **The King and Queen**.

GOOD FURNITURE

1916. Feb. Harris, William Laurel. "Industrial Art and American Nationalism," p. 74. Two illustrations (not known whether color or black and white) of **The Dream Garden**.

GOOD HOUSEKEEPING

1925. July. Maxwell House Coffee sepia advertisement, p. 129, **The Broadmoor**.

HARPER'S BAZAR

1895. Easter. Cover. Two girls in medieval gowns, holding Easter lilies in their hands, flank a scroll which bears the magazine title. Two smaller scrolls carry the word "Easter" and the year "1895."

1896. Easter. Gold Dust black and white advertisement on the back cover, signed. A young woman wearing a black blouse with huge leg-o'-mutton-sleeves, and white cap, collar, cuffs and apron, stands behind a store counter holding a box of Gold Dust cleansing powder. Boxes on the shelves and advertising posters are behind her. This ad bears the slogan: "Three of the greatest requisites of an enterprising housekeeper."

1914. Mar. Cover in color, **Griselda**.

——. **Mar.** Wilcox, Ella Wheeler. "Stairways and Gardens," a poem, p. 2, with small black and white **Griselda**.

1922. Mar. Jell-O color advertisement, verso of front cover, **The King and Queen**.

HARPER'S MONTHLY

1898. April. Humbert, Arthur C. "Photographing A Wounded African Buffalo," p. 655. The design around the photograph accompanying the article heading is believed to be Parrish's work.

1915. April. Black and white headpiece for "Contents." (This design was used in several issues.)

1928. May. Advertisement, 9th page, for a man's tie rack decorated with **Old King Cole** (St. Regis). Small photograph and description of the rack. (See Miscellanea.)

HARPER'S ROUND TABLE

1895. July. Cover in color, a soldier with a scroll and sword.

——. **Aug.** Reported to be cover, same as previous entry, in different colors. Unverified.

1897. Nov. Cover in black and white, 11½" by 8¼", two boys lounge over the Table of Contents.

1898. Dec. Cover in black and white, 7¾" by 5", two boys lounge over the Table of Contents.

1899. Mar. Cover, same as previous entry.

HARPER'S WEEKLY

1895. Dec. 14. Cover in gray and white. A chef, with arms akimbo, holds a plum pudding on a plate. A distant village is seen through

the small windowpanes behind him. The printed signature appears in the following form:

<div align="center">

F.

Maxfield

Parrish

1895

</div>

———. **Dec. 14.** Royal Baking Powder advertisement, back cover. A woman in Dutch costume, arms akimbo, holds a frosted cake on a plate. A distant village is seen through the small round windowpanes behind her. (Companion picture to the previous entry.)

1896. Apr. 11. Cover in black, white and green, a girl in right profile, wearing a plaid dress, rides a bicycle.

———. **Apr. 11.** Advertisement in black, white and green, a boy in checked knickers and jacket, rides a bicycle. (This is a companion picture to the previous entry.)

———. **Dec. 19.** Cover in sepia and blue. Two serving men in long blue coats and buttoned vests, carry small trays of refreshments. Between them, a whiskered man sits at a table, cutting into a plum pudding.

1897. Dec. 18. Cover in color, a man and his wife are enjoying the holiday feast.

1900. Dec. 8. His Christmas Dinner, p. 1171. A tramp stands before a wall, which is covered with advertisements for exotic foods, eating a sandwich from a basket.

1906. Apr. 14. Pottle, Emery. "The Flower In the Window Easter Morning," p. 513, black and white border design around the poem believed to have been created by Parrish.

1907. Dec. 14. Cover in color, a man and his wife are enjoying the holiday feast. Same as for Dec. 18, 1897, in different colors.

1908. Dec. 12. Cover in color, same as for Dec. 14, 1895.

HARVARD BULLETIN

1972. June. "American Art at Harvard," pp. 23-26, black and white **The Black Sheep**, from *Mother Goose In Prose*.

HEARST'S MAGAZINE

1912. June. Cover in color, **Jack the Giant Killer**, Jack and the giant sit together at a table, eating.

———. **July.** Cover in color, **The Frog Prince**, a youth and a large frog contemplate one another by a rocky mountain stream. In the background are an arched bridge, a fir tree, luminous mountains, and a shadowed town with a clock tower.

———. **Aug.** Cover in color, **The Story of Snow Drop**. A beautiful maiden lies in a glass casket, high on a rocky ledge. A scowling little gnome, leaning on his staff, keeps watch over her.

———. **Sept.** Cover in color, **Hermes**. The god Hermes stands with his snake-ringed staff, silhouetted against the deep blue sky and white clouds.

———. **Nov.** Cover in color, **The Sleeping Beauty**. Beauty and two handmaidens sleep on a porch as the Prince approaches.

1914. May. Cover in color, **Puss in Boots**. A calico cat, standing upright, with boots on his hind feet and a saddlebag under his arm, stands before a king on his throne. The king has his feet on a cushioned stool, his chin in his hand, and is attended by a servant standing behind him. All three characters are profiled against a castled town on a nearby mountainside.

1922. Mar. Jell-O color advertisement, p. unk., **The King and Queen**.

HOUSE AND GARDEN

1904. Apr. Henderson, Helen. "The Artistic Home of the Mask and Wig Club," pp. 168-74. Among the nine black and white illustrations are four of Parrish's work.

Mug rack decorations for Graduate Club members Brockie, Trotter and Bartol, consist of a small caricature beside each mug peg.

A ticket window decoration incorporates decorative banners and scrolls around a pointed-arch window. A pierrot is on either side, with clouds above it. (During a renovation of the theatre, the wall bearing this decoration had to be destroyed.)

The proscenium arch of the upstairs theatre is decorated with banners and scrolls. On each side is a robed youth in plumed cap, holding a shield; two white storks fly toward each other at the top.

A bulletin board design consists of two youths leaning upon, and conversing over, the blank board. A distant landscape with castles appears behind them. A mask and banners are at the base of the design.

1923. Dec. Jell-O color advertisement, verso of front cover, **Polly Put the Kettle On.** On a green table are the "makings" for a bowl of Jell-O. On the left a man sits expectantly on the edge of a green stool, a little girl beside him. On the right is Polly, teakettle in hand. Two black and white cats sit in the two lower corners. A shelf of pewter ware crosses the top of the picture.

HOUSE BEAUTIFUL

1923. June. Small black and white illustration, p. 698, **The Spirit of Transportation.**

THE ILLUSTRATED LONDON NEWS

1907. Aug. 24. Reported to be black and white illustration, **Summer.** Unverified.

1910. Dec. Christmas Number. Two color illustrations; p. 27, **Dies Irae**; p. 28, **The Reluctant Dragon**, both from *Dream Days.*

1913. Dec. Christmas Number. Color illustration, p. 11, **Its Walls Were as of Jasper (#2)**, from *Dream Days.*

1922. Dec. Christmas Number. Color illustration, p. 40, **A Departure**, from *Dream Days.*

INDEPENDENT

1907. Nov. 21. "Leading American Illustrators," p. 1201. In the picture section is a black and white illustration, **The Twenty-First of October**, from *Dream Days*.

INTERNATIONAL STUDIO

1898. Sept. "Review of Recent Publications," pp. 214-16. Two black and white illustrations; **Old King Cole** (*Mother Goose*), and **The Wond'rous Wise Man**, both from *Mother Goose In Prose*. Comments on Parrish's work.

1899. Dec. "American Studio Talk," pp. 22-24, black and white illustration, "I'm Jason, . . . and this is the Argo, . . .", from *The Golden Age*.

1906. July. Irvine, H. J. "Professor von Herkomer on Maxfield Parrish's Book Illustrations," pp. 35-43. Seven black and white illustrations:
"It was easy . . . to transport yourself, . . .", and "On to the garden wall . . .", both from *The Golden Age*.
A Saga of the Seas, and **The Twenty-first of October**, from *Dream Days*.
Villa Chigi, from *Italian Villas and Their Gardens*.
The Dinkey Bird, from *Poems of Childhood*.
"Blacksmiths . . .", from *Knickerbocker's History of New York*.
One color illustration, **Dies Irae**, from *Dream Days*.

1908. Feb. Advertisement for six calendar prints from *The Golden Age* in advertising section: "Special ornamental design in two colors, in artistic box. $2.50."

1909. Feb. Calkins, Ernest Elmo. "Second Annual Exhibition of Advertising Art," pp. cxlvi-cxlvii. Black and white photograph of the show, with the Parrish poster centered over the fireplace mantel. The poster, **"The Toy Show—Holiday Bazaar,"** is the same as **Toyland**.

1911. Jan. Brinton, Selwyn. "Modern Mural Decoration In America," pp. 175-90. One color illustration, **Old King Cole** (St. Regis).

1912. Aug. "A Note On Some New Paintings by Maxfield Parrish," pp. 25-26. Two black and white illustrations of **Florentine Fête Murals: Love's Pilgrimage**; the second illustration is of a couple standing on steps, looking up at three young people who are leaning over the balustrade above them.

THE LADIES' HOME JOURNAL

1896. July. Cover in sepia, of a maiden in medieval robes, standing in front of a great tree trunk in a forest. In the left background can be seen a distant castle. It's interesting to note that many of the design elements of Parrish's later, better-known works, are present in this first cover for *The Ladies' Home Journal*.

1901. June. Cover in black, white and yellow portrays a young couple strolling in a formal garden. A similar, but not the same, drawing is used to illustrate, "The Duchess At Prayer," *Scribner's Magazine*, Aug., 1900.

1902. Dec. Frontispiece in black and white, **The Sugar Plum Tree**, from *Poems of Childhood*.

1903. Feb. Frontispiece in black and white, **Seein' Things**, from *Poems of Childhood*.

——. **Mar.** Frontispiece in black and white, **The Little Peach**, from *Poems of Childhood*.

——. **May.** Frontispiece in black and white, **Wynken, Blynken and Nod**, from *Poems of Childhood*.

——. **July.** Frontispiece in black and white, **With Trumpet and Drum**, from *Poems of Childhood*.

1904. Sept. Cover in color. **Air Castles.** Inside the cover is the announcement that Parrish won a $1,000 prize for the original painting.

1905. Mar. A Circus Bedquilt, p. 11, with editor's instructions for making. This pattern by Parrish features zebras and acrobats on the borders, with a clown in each corner. Clowns, and acrobats with their juggling balls, form the center of the design.

1911. Nov. "A Girls' Dining Room of Maxfield Parrish Paintings," p. 1, announcement of the **Florentine Fête Murals.**

1912. May. Color representation of the girls' dining room, with the **Florentine Fête Murals** in place, representation *not* by Parrish. Two murals, by Parrish, reproduced in color, pp. 18, 19, **Love's Pilgrimage**; title unknown for the second one.

_____. **July.** Cover in color, one of the **Florentine Fête Murals** titled, **shower of Fragrance** (top half only shown), is of pierrots picking white flowers on a balustrade.

_____. **Dec.** Cover in color, a beckoning pierrot in white against a red background, which is one figure from **Call to Joy**, one of the **Florentine Fête Murals.**

1913. May. Cover in color, one of the **Florentine Fête Murals,** titled **Buds Below the Roses**, shows young people costumed for a party, posing on a flight of steps. Masses of roses are over their heads.

_____. **Nov.** Advertisement, p. 1, for reproductions of one of the **Florentine Fête Murals,** titled **Castle of Indolence**, 9¾" by 6", to be given with a subscription to the magazine. The scene shows a group of young people lounging around a short flight of steps on the right. At the left are trees, mountains and a cloudy sky, seen through an archway. Two girls look down on the gathering from an open upstairs window.

1914. June. Cover in color, one of the **Florentine Fête Murals,** titled **The Garden of Opportunity (#1)**. The picture has been cropped for this reproduction.

1915. Nov. "A Dream Garden In Glass—The Most Wonderful Favrile Mosaic Picture in America," p. 1. Article only, about **The Dream Garden**. No illustration.

———. **Dec.** "The Dream Garden: The Most Wonderful Favrile Mosaic Picture In America," between pp. 36-37. Double-page color illustration, **The Dream Garden**, the scene created by Parrish for Louis Comfort Tiffany.

1916. Dec. Djer-Kiss Cosmetics color advertisement, p. 62, a girl sits in a swing with bowers of roses over her head, and purple mountains in the distance.

1918. Jan. Edison-Mazda color advertisement, p. 81, **And Night is Fled**.

———. **Apr.** Djer-Kiss Cosmetics color advertisement, p. 73, a young girl dressed in white, crowned with a garland of flowers, sits on a rock in the forest watching three little elves.

———. **Dec.** Community Plate Silverware color advertisement, p. 86, two pages hold a box of silverware between them.

1919. Jan. Edison-Mazda color advertisement, p. 49, **The Spirit of Night**.

1920. Dec. Full-page color illustration, p. 22, of the end mural from the **Florentine Fête Murals**, which shows a gathering of many young people on the broad steps of a loggia, beneath open archways.

1921. Apr. Cover in color, part of one of the **Florentine Fête Murals** titled, **Sweet Nothings**, portrays a youth standing below a window talking to the girls within.

———. **Apr.** Djer-Kiss Cosmetics color advertisement, p. 52, a girl sits in a swing with bowers of roses over her head, and purple mountains in the distance.

———. **Nov.** Swift's Premium Ham color advertisement, p. 156, **Jack Spratt**.

1925. July. Maxwell House Coffee color advertisement, p. 67, **The Broadmoor**.

1930. Mar. Frontispiece in color. **White Birch**.

——**. June.** Cover in color, Girl Water Skier, which shows a girl water skiing.

——**. Oct.** Frontispiece in color, **Arizona**.

1931. Jan. Cover in color, Girl Snow Skier, which shows a girl snow skiing.

LIFE MAGAZINE

In the nineteenth century, and up through 1935, *Life Magazine* was published in a small format, approximately 11″ by 8½″, as opposed to the larger magazine it became in 1936. Many of the covers on the smaller magazine were the work of Parrish.

1899. Dec. unk. Cover in gold, cream and black, of two young men with decanter and glasses.

1900. Dec. 1. Cover in gold, cream and purple, Father Time is seated with a large book open on his lap. The ornate clock behind him wreathes his head like a halo. On either side of him stand attendants in purple jerkins and checked capes.

1904. Mar. 3. Cover in color, profile Saint Patrick sits on a rock, contemplating.

1905. Feb. 2. Cover in color, Saint Valentine writes a note with a quill pen.

1917. Sept. 13. Fisk Tires color advertisement, verso of the front cover, **The Modern Magic Shoes**. A boy dressed in pointed shoes, Robin Hood cap and flying cape, rides on a Fisk tire, in front of a picture of Rocky Mountain scenery.

——**. Nov. 6.** Reported to be Fisk Tires advertisement, p. and color unknown, **The Magic Circle**. Unverified.

1918. May 16. Fisk Tires color advertisement, verso of the front cover, **Fit for a King**.

1920. Dec. 2. Cover in color, three grotesque male servants walk in lock step, bearing bowls.

1921. Mar. 10. Advertisement, first page inside front cover, for coming Easter cover by Parrish.

_____. **Mar. 17.** Cover in color, **Humpty Dumpty** (*Life*), a smiling Humpty, dressed in high white collar and purple suit, sits cross-legged on a wall, with a teacup and saucer in his hands. A pewter teapot rests on the wall beside him, and a tree and distant scenery are behind him.

_____. **June 30.** Cover in color, **A Swiss Admiral**. A grotesque admiral, wearing spurs, poses with his telescope.

_____. **Aug. 25.** Cover in color, a happy fisherman with his cane pole and a bucket.

_____. **Oct. 13.** Cover in color, **Evening** (nude).

_____. **Nov. 10.** Get Together Number. Cover in color, two youths dressed in purple chat above a central panel, which bears the title of the issue. (This same design was used by Edison-Mazda for several of their advertisements.)

_____. **Dec. 1.** Cover in color, a trio dressed in polka dots bring in the festive foods.

1922. Jan. 5. Cover in color, **A Man of Letters**. A sign painter in a bowler hat sits on a board which crosses the cover, and paints the magazine title with green paint.

_____. **Apr. 6.** Cover in color, **Morning**.

_____. **May 11.** Bookstuff Number. Cover in color, two young men with teacups and a bowl of fruit, are pictured above the central panel which carries the magazine title.

————. **June 22.** Cover in color, a green-eyed man wearing a bowler hat, holds and stands among letters which spell, "*Life*."

————. **July 6.** *Life's* Title Contest, p. 21, for the best title for the June 22 cover. Black and white illustration of the cover.

————. **July 20.** Cover in color, **Tea? Guess Again.** Profile of a man in a red bathrobe, sitting on a stool drinking from a teacup.

————. **Aug. 24.** Cover in color, **Her Window.** Pierrot, with his mandolin, sits on a wall under overhanging branches.

————. **Oct. 19.** Cover in color, **Masquerade**, a masked figure in black and white checks extends his red cape behind him.

————. **Dec. 7.** Cover in color, three figures in purple carry silver serving pieces.

1923. Mar. 1. Cover in color, **A Dark Futurist**, a bespectacled artist in a green robe faces the viewer squarely.

————. **Mar. 29.** Cover in color, a girl in a white robe clings to rocks above a rushing stream. Trees are on the opposite shore. (Similar to **Canyon**.)

————. **Aug. 30.** Cover in color, a chef samples the pot against a black and white checked background.

1924. Jan. 31. Cover in color, **A Good Mixer**, profile of a bespectacled artist, in an orange smock, frowning at his canvas, as a black cat sits beneath it.

LIFE MAGAZINE (Large format)

1938. Oct. 31. "American Art Comes of Age," pp. 27-30. Small black and white illustrations, **The Dinkey Bird**, from *Poems of Childhood*.

1940. June 24. "Philadelphia, The Republican Party Has A Homecoming," pp. 62-73. Small black and white photograph of

The Dream Garden mosaic in the Curtis Publishing Company building.

1945. Jan. 1. "Calendars," pp. 41-46. Small color illustration, **Sun-Up**.

THE LITERARY DIGEST

1918. May 11. Fisk Tires black and white advertisement, p. 36. **Fit for a King**.

1936. Feb. 22. "Parrish's Magical Blues," pp. 24-25. Three black and white illustrations:
Arizona
Belles Lettres, a mailbox design, shows a young page, in dark full-sleeved blouse with white collar and cuffs, and a figured skirt, holding a box with a large round hole in it. About his feet winds a scroll bearing the words, **Belles Lettres**.
Sugar Hill, Late Afternoon (single title), is of a single tree on the right, standing at the crest of a rocky hill against a clear sunset sky. Several old fence posts lie and stand on the left.

THE LOS ANGELES TIMES

1967. Nov. 5. Seldis, Henry J. "High Camp Not the Label For Parrish," p. 46. Three black and white illustrations: **A Good Mixer; Sheltering Oaks;** and **Sing a Song of Sixpence**.

THE MAGAZINE OF LIGHT (House organ for General Electric Co.)

1931. Feb. Cover in color, **The Waterfall**.

1932. Summer. Cover in color, **Sunrise** (Edison-Mazda).

McCALL'S

1922. Mar. Jell-O color advertisement, p. unk., **The King and Queen**.

McCLURE'S

1904. Nov. Cover in color, **Señor Johnson**, a cowboy on a standing horse is enclosed within a circle.

———. **Nov.** White, Stewart Edward. "The Rawhide," p. 21. Black and white story illustration, **Señor Johnson**, same as previous entry, in a rectangular format.

———. **Dec.** White, Stewart Edward. "The Rawhide," p. 175. Color illustration, **The Roundup Crew**, shows a rocky foreground, with two cowboys on horseback outlined against mountains pink in the sunrise.

1905. Jan. Cover in color, two draped figures with a distant scene between them.

———. **Jan.** White, Stewart Edward. "The Rawhide," p. 175. Color illustration, "He swung himself into the saddle . . .", a lone horseman rides between colorful cliffs.

———. **Mar.** Cover in color, two draped figures with a distant scene between them.

———. **May.** Same as previous entry.

1906. July. Same as previous entry.

1907. Jan. Same as previous entry.

THE MENTOR

1914. Sept. Hoeber, Arthur. "American Mural Painters," pp. 1-11. Three small black and white illustrations of **Florentine Fête Murals: Call to Joy**; titles unknown for the remaining two.

1922. Mar. "The Story of the Arabian Nights," pp. 13-28. Four small color illustrations: **The Fisherman and the Genie; Prince Codadad; Cassim;** and **The Young King of the Black Isles.** One double-page color illustration, **The City of Brass.**

1927. June. Merrill, Charles. "Dreams Come True In His Workshop," pp. 20-22. Black and white illustration, **Prince Agib**, from *The Arabian Nights*. Two photographs of the artist.

METROPOLITAN MAGAZINE

1904. Dec. LeGallienne, Richard. "Once-Upon-A-Time," p. unk. Black and white story illustration of an ogre, and a knight on horseback.

1917. Jan. Cover in color, gowned and girdled lass stands with an apple in her hand, between two tree trunks. Boulders in the foreground, intense blue background.

MODERN PRISCILLA

1924. Jan. Jell-O color advertisement, back cover, **The King and Queen**.

MON JOURNAL (French publication)

1900. unk. Black and white illustration, p. 81, **A Journey Through Sunny Provence**, from *Troubadour Tales*.

NEW COUNTRY LIFE

1918. May. Fisk Tires color advertisement, p. 80-c, **Fit for a King**.

NEW HAMPSHIRE TROUBADOUR (House organ for State of New Hampshire Planning and Development Commission.)

1938. Apr. Black and white illustration, **New Hampshire—Land of Scenic Splendor**, p. unk.

——. **June.** Article only, p. 15, mentions that the publication's yearbook for 1938 has a cover by Parrish.

——. **Yearbook.** Cover in color, title unknown.

1939. Mar. Black and white illustration, p. unk., advertisement for poster, **New Hampshire—Land of Scenic Splendor.**

———. **Summer.** World's Fair Edition. Cover in color, **New Hampshire—Land of Scenic Splendor.**

1940. Feb. Cover in color, **New Hampshire—Winter Paradise.**

———. **Apr.** Article, p. 12-13, by Parrish, concerning the poster, **New Hampshire—Winter Paradise.**

NEWSWEEK

1935. Sept. 28. "Old King Cole Beams Down Again On Convivial Gatherings," pp. 36-37. Black and white illustration, **Old King Cole** (St. Regis).

1960. June 6. "We Know Him Well," pp. 110-11. Black and white illustration, **Old King Cole** (St. Regis). Portrait of the artist.

NEW YORK HERALD TRIBUNE

1936. Feb. 16. "Recent Work by Maxfield Parrish," sec. 5, p. 10, col. 1, black and white illustration, **Elm, Autumn** (single title).

THE NEW YORK TIMES

1964. June 7. Canaday, John. "Maxfield Parrish, Target Artist," p. X-21. Two black and white illustrations, **The Idiot,** and **Jason and the Talking Oak,** from *The Wonder Book.*

1966. Mar. 31. Obituary, p. 39. Black and white illustration, **Old King Cole** (St. Regis). Photograph of the artist.

THE NEW YORK WORLD

1926. Jan. 3. (Sunday Supplement.) Reported to be color illustration, **The Gardener** (*Knave of Hearts*). Unverified.

VOL. XXXVIII No. 2 MAY, 1901 PRICE, 25 CENTS

OUTING

AN ILLVSTRATED MAGAZINE
OF SPORT TRAVEL ADVENTVRE
AND COVNTRY LIFE
EDITED BY CASPAR WHITNEY

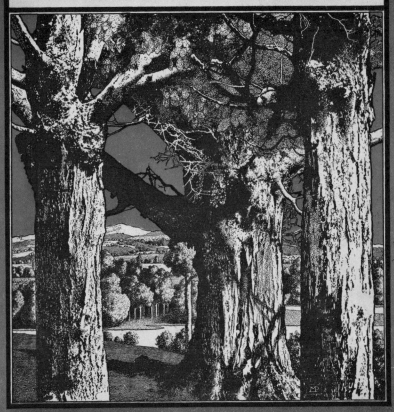

NEW YORK AND LONDON

Maxfield Parrish's illustrated cover design for *Outing* magazine, May 1901

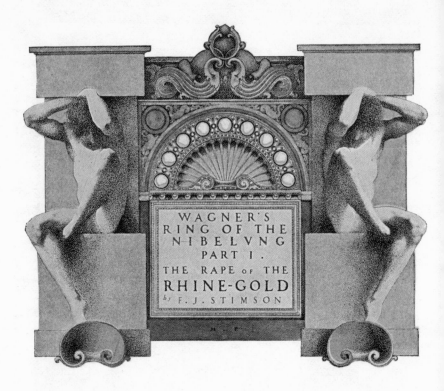

Two decorations by Parrish which appeared in *Scribner's* magazine, December 1898 as illustrations for F. J. M. Stimson's poetic translation of Wagner's *Ring of the Nibelung*

OUTING MAGAZINE

1900. June. Cover in black, white and green, three large tree trunks against a forest background.

1901. May. Cover in black and white, same as previous entry.

1904. Nov. Cover in black and white, same as previous entry.

1905. Feb. Cover in black, white and yellow. Same as previous entry.

1906. Sept. Cover in black, white, red and gold, same as previous entry.

____. Nov. Cover in color, a man studies the flower in his hand. He is seated in a wall-niche under the spreading branches of a leaf-less tree, and is flanked by two stone lions.

____. Dec. Black and white column heading for, "The View-Point," same description as the previous entry.

1907. July. Cover in color, same description as the previous entry, except that the tree has been deleted.

____. Oct. Cover in color, same description as the previous entry, with the addition of a fanciful scarab design in the red sky above the figure.

____. Nov. Cover in color, same description as for Nov., 1906.

1908. June. Cover in color, same description as for July, 1907, except that the tree has been replaced by a fanciful scarab design in a cloudy sky.

1912. July. Cover in color, same description as for June, 1900.

THE OUTLOOK

1899. Dec. North, Ernest Dressel. "A Group of Young Illustrators," p. 166. Black and white illustration, **The Roman Road**, from *The Golden Age*.

1904. Dec. Moffat, William. "Maxfield Parrish and His Work," pp. 838-41. Two black and white illustrations, **The Fly-Away Horse**, and **The Sugar Plum Tree**, both from *Poems of Childhood*.

PENCIL POINTS

1935. Oct. Small, black and white illustration, p. 32, **Old King Cole** (St. Regis).

PEOPLE'S HOME JOURNAL

1922. Oct. Jell-O color advertisement, p. unk., **The King and Queen**.

PICTORIAL REVIEW

1922. Jan. Reported to be Jell-O color advertisement, p. unk., **The King and Queen**. Unverified.

1924. Feb. Jell-O color advertisement, p. unk. **Polly Put the Kettle On**.

THE POSTER

1899. Mar. Pollard, Percival. "American Poster Lore," pp. 123-27. Black and white illustration of the Adlake Camera advertisement, a horizontal scene of a boy and a girl seated opposite each other on the ground, legs outstretched, toes touching. The boy is taking the girl's picture with a box camera. Trees and castles are in the background. Beneath the picture is printed: **"The Adlake Camera** 4" by 5" with twelve plate holders." There is a small paragraph on Parrish.

REAL WEST MAGAZINE

1969. Aug. Betz, Les. "The Western Art of Maxfield Parrish," pp. 40-43. Three black and white illustrations: **Bill Sachs; Pueblo Dwellers;** and **Formal Growth in the Desert,** all from "The Great Southwest." Two portraits of the artist.

SAN FRANCISCO CHRONICLE

1973. Mar. 1. Frankenstein, Alfred. "Reminder of Fred Maxwell," p. 42. Small black and white **Canyon.**

SANTA BARBARA NEWS-PRESS

1967. Sept. 17. Ames, Richard. "Maxfield Parrish For Fine Technique," p. C-10. Black and white illustration of **June Skies,** a summer landscape with a tall tree on the right, and high cumulus clouds reflected in a foreground stream.

THE SATURDAY EVENING POST

1913. Nov. 22. Advertisement, p. 54, for reproduction of one of the **Florentine Fête Murals,** titled **Buds below the Roses,** to be given with a subscription of the magazine. The reproduction has an elaborate border design, and measures 9½″ by 6″.

1918. Dec. 7. Community Plate Silverware color advertisement, p. 83, two pages hold a box of silverware between them.

1920. Jan. 3. p. 172, small black and white **Prometheus.**

1924. Sept. 20. Edison-Mazda color advertisement, p. 66, of two youths dressed in purple, chatting above a central panel which bears the advertising.

____. Dec. 27. General Electric color advertisement, p. 50, shows a group of shoppers looking in a store window at G-E products. The Edison-Mazda design of two youths chatting above a central panel is prominently displayed in the center of the window.

1925. Feb. 7. Edison-Mazda color advertisement, p. 86, of two youths dressed in purple, chatting above a central panel.

———. **July 4.** Maxwell House Coffee sepia advertisement, p. 83, **The Broadmoor**.

———. **Dec. 5.** Advertisement, p. 209, for reproduction of one of the **Florentine Fête Murals** to be given with a subscription to the magazine. The reproduction offered is of the end mural, title unknown, 7″ by 11″. (See *Ladies' Home Journal*, Dec., 1920.)

THE SATURDAY REVIEW

1964. Mar. 14. Gillett, G. Elizabeth. "His Skies Are Blue— Maxfield Parrish At Ninety-Three," pp. 129-30. Two small black and white illustrations: **The Garden of Allah**; and a catalog cover, a girl in a plumed hat and fashionable ensemble, is surrounded by a formal design. On a wide scroll above her head the following words appear, "Wanamaker's, Goods and Prices, Spring and Summer, No. 42. 1897."

SCRIBNER'S MAGAZINE

1897. Aug. Grahame, Kenneth. "Its Walls Were as of Jasper," pp. 157-68. Twelve black and white line and stipple illustrations. (Grahame's *Dream Days* has a chapter titled, "Its Walls Were as of Jasper," but none of the following described illustrations appear in that book.)

P. 157, titled design of a boy sitting cross-legged before a fireplace with a book open on his knees. The story title appears on the face of the fireplace, the boy sits on a decorative scroll.

Pp. 158-59, these two illustrations are on facing pages. Decorative scrolls and shields cross the pages below the illustrations, and enhance the outer page borders.

P. 158, "A very fascinating background it was, . . .", shows four knights on caparisoned horses, lances raised. Behind them is a turreted village wall and gateway, with the town houses and castles rising behind it. A small boy sits cross-legged on the design in the lower left corner.

P. 159, "The hill on one side descended to the water, . . .", is of

SCRIBNER'S MAGAZINE

a galleon, with full sail and flying banners, anchored in a calm bay. Trees and houses on the hillside comprise the background. A small boy sits cross-legged in the lower right corner.

P. 160, "Edward was the stalwart, . . .", portrays a bearded man in a wide-brimmed hat, powder horn at his belt, aiming a rifle at a buffalo.

P. 161, "You could just see over the headland, . . .", depicts a small boy, standing in the rigging of a sailing vessel, looking out over a town and a distant bay filled with sails.

P. 162, "As we eventually trundled off, . . .", is of a small boy and a young woman seated in a two-wheeled buggy. In the background is a brick wall, a large house and a gnarled tree.

P. 163, "A grave butler who . . .", shows a formal butler in profile, standing between pillars at an open doorway. Shadows of a woman and a child foretell the visitors.

P. 164, "In ten seconds they had their heads together . . .", is of a living room with a fireplace on the left. Two women are seated beneath an ornate picture frame. A small boy sits uneasily on the edge of his chair.

P. 165, "I glanced carefully around, . . .", shows a small boy standing at the edge of a wide portiere, about to open the door behind it. A large urn stands on the right.

P. 166, "When I got the book open, . . .", depicts a boy on his hands and knees before a fireplace, looking at a big book. A coal scuttle stands on the right, stained-glass windows are on the left.

P. 167, "From the deck I should see . . .", portrays a boy holding onto the rigging of a sailing vessel with his left hand, and onto his hat with his right hand. From beneath the sail his view is across the sea to a castled island.

P. 168, is the tailpiece, which shows a boy standing before a large book which is lying open on the floor. Decorative scrolls, two knights on caparisoned horses and a distant town, are in the background, beneath the fireplace mantel. The boy wears a startled expression, as each of his arms is held in the grasp of a giant hand.

1897. Dec. Cover in color, three stylized figures present festive foods on silver service. The center figure is a man wearing a purple

SCRIBNER'S MAGAZINE

and lavender checked coat with a wide white collar. He bears the
plum pudding on a tray. The pages on either side of him are
identically dressed in green coats with Elizabethan collars.

_____. **Dec.** Royal Baking Powder color advertisement, outside of
back cover, states, "Makes the good things for Christmas," and
shows a full-face chef measuring Royal Baking Powder into a
bowl under the watchful eyes of a black cat. Signed.

1898. Nov. Goodale, Grace. "At An Amateur Pantomime," p. 528.
Black and white line and stipple poem illustration of a young
woman retreating from the advances of a pierrot.

_____. **Dec.** Stimson, F. J. "The Rape of the Rhine-Gold," pp. 74-89.
Eight pages with sixteen monotone illustrations and page decora-
tions.
P. 74, the title page features a formal design around the title,
flanked by a seated male nude on either side.
P. 75, an ugly bearded gnome, with a mall hung from his belt,
climbs in a rocky canyon.
P. 76, is a view into the black depths of a rocky canyon; no
figures.
Pp. 77 and 78, headpiece design consisting of two nude women
seated opposite each other with bowed heads and flowing black
hair. A classic seashell design is between them. P. 77 shows the
figures facing each other; p. 78 shows the figures facing the
viewer.
P. 79, one distinct, and two indistinct, female nudes with long,
floating black hair, seem to be swimming in a void.
P. 80, an ugly gnome with popping eyes grasps at a glow coming
from under a boulder.
P. 81, a tall majestic Viking stands holding his lance upright
beside him. He wears a long cape and a winged helmet. Nearby
trees and distant castles are behind him.
P. 82, a scene with two trees in the foreground is outlined
against gray clouds to soar against a blue sky with white clouds.
Pp. 83 and 84, page heading designs of alternate shields and
winged helmets.

SCRIBNER'S MAGAZINE

Pp. 85 and 86, full page design surrounds the text. At the top, a male and female nude kneel, facing away from each other. A classical shell design is between them. At the bottom three shields are prominent in the design.

Pp. 87 and 88, a narrow, formal design continues across the top of both pages. On the outer side of each page is a swirled shell, against which a male nude sits, hands on knees, with long hair hiding his face.

P. 89, a classic column flanks each side of the text. At the top of each column the design includes a seashell; at the bottom is a design with hearts. Within the columns, which are dark at the top and light at the base, are nebulous shapes.

1899. Apr. Cover in color, a maid sits by a sundial.

————. **Aug.** Cover in color, a youth in robes, with a book in his lap, sits beside a lily pool. Trees are in the background.

————. **Oct.** Cover in color, a kneeling maid picks grapes. A village is in the background.

————. **Dec.** Cover in color, a single shepherd, with his sheep, shields his head with his purple cape.

1900. Aug. Wharton, Edith. "The Duchess At Prayer," pp. 148-63. Four black and white story illustrations:
 "The Duchess's apartments are beyond, . . .", shows an old man standing on a pillared portico, holding a large ring of keys.
 "They were always together . . .", depicts a couple strolling in a large formal garden. (See Illustrations In Periodicals, *Ladies' Home Journal*, June, 1901.)
 "He was the kind of a man . . .", portrays a priest spying around great pillars at a young woman.
 The final scene bears no title, and shows a courtier, prostrate with despair, lying at the foot of a flight of steps.

————. **Aug.** Peabody, Josephine. "Play Up Piper," p. 189. Black and white poem illustration, a piper sits on the frame around the

SCRIBNER'S MAGAZINE

poem. A tree and a full moon are behind him, theatrical masks are below him.

———. **Oct.** Cover in color, a lass with an apron filled with fruit sits on a wall under a full moon.

———. **Dec.** Cover in color, shepherd lad and wise men, bearing gifts.

———. **Dec.** Royal Baking Powder color advertisement, outside of back cover, a profile chef with a large bowl and spoon stirs beside a sack of baking powder. This advertisement has no signature, other than that of workmanship and color, which seems undoubtedly Parrish.

1901. Aug. Quiller-Couch, A. T. "Phoebus On Halzaphron," pp. 163-76. Eight black, white and yellow story illustrations, plus heading and tailpiece.

The heading consists of the robed figure of a youth with a lyre, superimposed over a distant landscape.

P. 165, "The rolling downs . . .", is a dark picture of a horseman in a grove of trees.

P. 166, "And their King . . .", depicts a medieval king standing on a high crag, observing the ships at sea below him.

P. 167, "Through the night she calls . . .", a beautiful maiden with blowing draperies stands in the sea, beckoning to a distant vessel.

P. 168, "One black noon . . .", is of a rocky, offshore island at the edge of the sea. A straggling line of men make their way over the wet sand to the island.

P. 169, ". . . at low water level and demanded . . .", is of four men standing dejectedly on an ocean beach. One man walks with a long cane.

P. 170, "Twilight had fallen . . .", two trees and a boulder, are outlined against the seashore and a sky filled with billowing clouds.

P. 171, ". . . rose and took his farewell," two men, one with a halo, part company on a sandy beach. Behind them are breakers, an offshore island, and a full moon breaking through clouds.

P. 172, ". . . and drew aside behind a rock . . .", a young man

"The Duchess's Apartments are beyond" is the caption for this drawing by
Parrish to illustrate Edith Wharton's story "The Duchess at Prayer",
Scribner's, August, 1900

"Through the night she calls to me, luring them down to their death" is the caption for this Parrish illustration for "Phoebus on Halzaphron" by A. T. Quiller-Couch, *Scribner's*, August 1901

SCRIBNER'S MAGAZINE

stands in profile within branches of shrubbery, outlined against a full moon which hangs over the background sea.

The tailpiece shows a bearded, robed man, with a halo, raising his arms in benediction. In his left hand is a cross. Behind him is the sea and an offshore island.

1901. Dec. Cover in color, two men seated at a table with a fruit bowl between them are attended by a waiter with a coffee pot.

_____. **Dec.** Frontispiece in color, "The Cardinal Archbishop Sat on His Shaded Balcony," from *The Turquoise Cup.*

_____. **Dec.** Smith, Arthur Cosslett. "The Turquoise Cup" Two black and white pictures: p. 671, title and head piece, Venetian scene with sailboat; and p. 689, "Lady Nora and the Cardinal . . .", shows a clergyman and a lady standing under the high ceiling of a cathedral.

_____. **Dec.** Royal Baking Powder color advertisement, outside of back cover, a chef with flowing red scarf walks along carrying a basket of groceries in one hand, and a sack in the other. In the basket is a red can of baking powder, and a package bearing the initials, "M. P."

1902. Dec. Frontispiece in color, an Arab stands at dusk by a tiny fire, from *The Desert.* (This story is included in the book *The Turquoise Cup.*)

1903. July. Davies-Ogden, A. M. "Romance," p. 1. Frontispiece poem illustration in color, **Aucassin Seeks for Nicolette.**

_____ **Dec.** Wharton, Edith. "A Venetian Night's Entertainment," p. 641. Black and white headpiece; and color illustration of two young men enjoying a drink in a crowded tavern which is lighted by orange lanterns.

1904. Sept. Reported to be an illustration of a future cover by Parrish within this issue. Unverified.

SCRIBNER'S MAGAZINE

_____. **Oct.** Fiction Number. Cover in color, a young girl picks grapes under a trellis.

_____. **Dec.** Graves, William Lucius. "The Vigil-At-Arms," p. 640, frontispiece poem illustration, a robed man stands with his lance in a pillared hall.

1905. Aug. Dwight, H. G. "Potpourri," p. 232. Color frontispiece poem illustration, a nude figure bends over to examine roses in a garden.

_____. **Oct.** Reported to be an advertisement, p. unk., for prints from *Poems of Childhood.* Unverified.

1906. Apr. Symons, Arthur. "The Waters of Venice;" facing pp. 385 and 388, two color illustrations: "On the other side of the water Venice begins," is of the Venetian skyline above the water (pale and weak in color); "Venice—Twilight," shows a sailboat near the silhouette of a building (strong and dark in color).

1907. Aug. Frontispiece in color, **Old Romance**, a profile nude woman stands beside a lake, with trees and a full moon in the background.

1910. Aug. Marsh, George T. "The Errant Pan," p. 128. Color illustration, **The Errant Pan**.

1912. Aug. Watson, Rosamund M. "The Land of Make-Believe," p. 129. Facing poem illustration in color, **The Land of Make-Believe**.

1923. Aug. Fiction Number cover in color, a nude girl with a garland of flowers crowning her long black hair, is seated beneath the trees, reading a magazine. She faces east. This is the prize winner for the *Scribner's Magazine* poster contest in 1897.

1937. Jan. *Scribner's Magazine* 50th Anniversary Number. Color illustration, p. 69, **The Errant Pan**.

SHOW—THE MAGAZINE OF THE ARTS

1964. May. Alloway, Lawrence. "The Return of Maxfield Parrish," pp. 62-67. Three black and white illustrations: **The Idiot**; **Penmanship**; and *Scribner's* Christmas poster.
Six color illustrations: **The Boar's Head**; **Jason and the Talking Oak**, from *The Wonder Book*; **The Land of Make-Believe**; **The Lantern Bearers**, from **The Golden Treasury**; **The Tourist**; and **Winter**. Photograph of Parrish.

SOCIETY OF ILLUSTRATORS—BULLETIN

1964. Apr. Cover in black and white **Father Knickerbocker**, from *Knickerbocker's History of New York*.

ST. NICHOLAS MAGAZINE

1898. Dec. Stein, Evaleen. "The Page of Count Reynaud," p. 91 (a chapter from *Troubadour Tales*). Black and white illustration, **A Journey Through Sunny Provence**.

1900. Nov. Dunbar, Aldis. "A Ballad In Lincoln Green," p. 27, black and white poem illustration, **A Quarter Staff Fight**. Two men fight with staves as a girl in the background weeps.

1903. Dec. Twose, George M. R. "The Three Caskets," p. 121. Black and white story illustration of an Egyptian stone-carver and his companion.

1906. Sept. Morgan, May. "The Sandman," p. 978, black and white poem illustration, **The Sandman**.

1910. Nov. Macy, Arthur. "The Sandman," p. 80, black and white poem illustration, **The Sandman**.

1914. Dec. Ames, Joseph. "Molly's Sketch Book—And Mine," pp. 120-127, black and white illustration of a page from an autograph book, p. 121, showing a Sherlock Holmes-type figure, with umbrella and satchel, signed, "Maxfield Parrish. 1898."

1922. Mar. Jell-O color advertisement, p. unk., **The King and Queen**.

1925. Mar. Espenhain, Frank K. "The Sandman," p. 544, black and white poem illustration, **The Sandman**.

STUDIO INTERNATIONAL

1964. Aug. Ashton, Dore. "The World's Greatest At the M. M. A.," pp. 86-89, black and white illustration, **Penmanship**. Short text on Parrish.

SUCCESS

1901. Dec. Cover in color, a man and two boys, bundled in winter clothing, are walking in front of a snowbank, carrying groceries. A full moon is rising above them.

SURVEY

1929. Aug. P. 486, full-page black and white illustration of Parrish's first sale, Clowns (1893). A foreground clown balances on a small ball. Behind him others pose around a larger ball, atop of which sits a little clown, with a fanciful parrot in each hand. In the background several smaller, less distinct clowns are engaged in clownish antics.

TIME

1964. June 12. "Grand-Pop; At Manhattan's Gallery of Modern Art," p. 76, two small black and white illustrations; **The Gardener** (*Collier's*), and **Arithmetic**. Photograph of Parrish.

TOWN AND COUNTRY

1918. May. Reported to be Fisk Tires advertisement, p. and color unk. Unverified.

1919. Aug. Reported to be Fisk Tires color advertisement, **Mother Goose** rides through the sky on a Fisk Tire. Unverified.

WOMAN'S HOME COMPANION

1918. Mar. Reported to be Djer-Kiss Cosmetics advertisement, young girl dressed in white, crowned with a garland of flowers, sits on a rock in the forest watching three little elves. Unverified.

1921. Apr. Ferry's Seeds color advertisement, p. 44, **Peter Piper**. Peter is seated cross-legged, holding a box full of green peppers. This is one of four advertisements painted by Parrish for Ferry's Seeds.

THE WORLD'S WORK

1918. Feb. Edison-Mazda color advertisement, inside back cover, **And Night is Fled**.

———. Dec. Reported to be Community Plate Silverware advertisement, p. unk., two pages hold a chest of silverware between them. Unverified.

1919. Dec. Reported to be Fisk Tires black and white advertisement, p. unk. **The Magic Circle**. Unverified.

YANKEE MAGAZINE

1935. Dec. Cover in color, **White Birch**.

1968. Dec. Cover in color, **Church at Norwich** (also titled **Peaceful Night**).

YOUTH'S COMPANION

1919. Feb. 20. Ferry's Seeds color advertisement, inside back cover, **Peter, Peter, Pumpkin Eater**.

1924. Jan. 3. Reported to be Jell-O color advertisement, p. unk., **Polly Put the Kettle On**. Unverified.

PAMPHLETS AND CATALOGS

The Artist Reacts: 6 Film Series. Syracuse, New York: Syracuse University, Educational Film Center. 9″ square. 6 pp. Color illustration, p. 3, **Daybreak**, 5½″ by 9″.

The Bridal Not. Philadelphia: University of Pennsylvania, 1912. 10″ by 6¾″. 6 pp. This is a theatre program for one of the performances of the Mask and Wig Club. Cover in lavender, sepia and white, is a copy of the decoration Parrish painted around the ticket window of the Club. The pointed-arch window is surrounded by decorative banners and scrolls, with a pierrot on either side, and white clouds above it. (During a renovation of the theatre, the wall bearing this decoration had to be destroyed.)

Dodge Publishing Company advertising pamphlet. New York: 1912. 10″ by 7″. Cover in black, white and green. **The Idiot.** 6¼″ by 4½″. Listed in the Dodge pamphlet under "Parrish Booklets" is the following notice:

"A series of dainty booklets, each with a cover designed by Maxfield Parrish. *A Friend's Greeting. Joy Be With You. Old Friends Are Dearest. Thoughts and Good Wishes.* 3½″ by 7½″. Paper boards, 50 cents net."

The booklet pictured as an example shows **Prince Codadad**.

The Dream Garden. Louis Comfort Tiffany. Philadelphia: The Curtis Publishing Company, 1915. This brochure discusses the design by Parrish, and the mosaic by Tiffany, **The Dream Garden,** with illustration.

A Friend's Greeting. New York: Dodge Publishing Company, 1912. 7½″ by 3½″. Cover in color. (See Dodge Publishing Company book catalog.)

Jell-O recipe booklet. LeRoy, New York: The Genesee Pure Food Company, 1924. 4½″ by 6¼″. 12 pp. The front cover bears the color advertisement, **Polly Put the Kettle On**; the back cover shows the color advertisement, **The King and Queen**. Elements from these two designs appear in black and white on the inner pages.

Joy Be With You. New York: Dodge Publishing Company, 1912. 7½″ by 3½″. Cover in color. (See Dodge Publishing Company book catalog.)

Maxfield Parrish. Boston: The Vose Galleries, 1968. 6″ by 9″. 8 pp. Exhibition catalog. Text on the artist, bibliography, and eleven black and white illustrations: The End; Lobsters With Cook; and **Potato Peelers**; all from *The Knave of Hearts.* Also **Cadmus**, from *The Wonder Book.* **Lantern Bearers**, from *The Golden Treasury.* **Church at Norwich**; **Freeman Farm**; **Hilltop Farm, Winter** (single title); **The Land of Make-Believe**; **Masquerade**; and **The Old Glen Mill**.

Maxfield Parrish—May 4-26, 1964. Vermont: Bennington College, 1964. 8½″ by 5¾″. 4 pp. Exhibition catalog. Two black and white illustrations: **Arithmetic**; and **Cadmus**, from *The Wonder Book.* Text on the artist.

Maxfield Parrish—A Retrospect. Springfield, Massachusetts: The George Walter Vincent Smith Art Museum, 1966. 8″ by 10″. 20 pp. Text on the artist, bibliography, portrait, and poem by Richard Butler Glaenzer, "To Maxfield Parrish." Ten illustrations in sepia: **Arithmetic; Arizona; Cadmus,** from *The Wonder Book*; **The Dream Garden; The Errant Pan; The Idiot; Jack Frost; The Land of Make-Believe; The Lantern Bearers**, from *The Golden Treasury*; and **Penmanship.**

Maxfield Parrish, A Retrospective. Syracuse, New York: Syracuse University, 1966. Flyer advertising exhibit from April 8-28,

folds three times. Printing on one side; **The Idiot**, in color, on the other.

Now Listen Here. Philadelphia: University of Pennsylvania, 1972. 11″ by 8½″. 18 pp. Theatre program for the 84th annual production of the Mask and Wig Club. P. 25, black and white **Old King Cole** (Mask and Wig), center panel only, showing the three fiddlers.

Old Friends Are Dearest. New York: Dodge Publishing Company, 1912. 6¼″ by 5″. 17 pp. Cover in color, **The Argonauts in Quest for the Golden Fleece**, from *The Wonder Book*; frontispiece in color, **The Young King of the Black Isles**, from *The Arabian Nights*.

Parrish Blue. Chicago: International Film Bureau Inc., n.d. 8½″ by 11″, single sheet. Printing on one side describes the film, "Parrish Blue;" reverse bears the color print, **Daybreak**, 5½″ by 9″. Film available for rent or purchase.

The Return of Maxfield Parrish. 1870-1966. Boston: The Vose Galleries, 1967. 6″ by 8¼″. 8 pp. Exhibition catalog. Text on the artist, bibliography, and eleven black and white illustrations: **Birches in Winter; Cadmus**, from *The Wonder Book*; **Church at Norwich; Cook With Steaming Pot of Soup**, The End, and **Musician Playing Lute**, from *The Knave of Hearts*; **Ecstacy; Hilltop Farm, Winter** (single title); **The Idiot; The Land of Make-Believe;** and **Sing a Song of Sixpence.**

Scribner's New Books For the Young, 1899-1900. New York: Charles Scribner's Sons, 1900. 8⅜″ by 6″. 24 pp. Cover drawing in black and white line and stipple shows two youths seated on a wall, one with a book. The background is of orange and white checks.

Sterling Bicycle catalog. Chicago: Sterling Cycle Works, 1898. 8″ by 5″. 16 pp. Cover in monotone green of a robed girl holding a sign which bears the slogan, "Built Like A Watch."

Success magazine advertisement. New York: The Success Company, 1902(?). 4¾″ by 13⅜″, folded in three places to make a booklet 4¾″ by 3⅜″. Open full-length it shows black and white advertising for the magazine on one side; four copies of *Success* covers

in color, for the year 1901, on the other side. The December, 1901, cover is by Parrish. (See Illustrations In Periodicals, *Success*.)

Thoughts and Good Wishes. New York: Dodge Publishing Company, 1912. 7½″ by 3½″. (See Dodge Publishing Company book catalog.)

Very Little Red Riding Hood. Philadelphia: University of Pennsylvania, 1897. 10″ by 7″. This is a theatre program for one of the performances of the Mask and Wig Club. The cover illustration, not known whether in color or black and white, **Very Little Red Riding Hood.**

Headpiece by Maxfield Parrish for *Collier's* magazine, March 25, 1905

MISCELLANEA

Miscellanea is just what you would expect it to be—sources and objects which fit into no other category in the *Guide*.

Address Label. Cream-colored manila wrapping paper used by Parrish to package prints for mailing, bears hand-lettered address. In the upper left corner: **From Maxfield Parrish: Windsor: Vermont** The center address:

> **Mr. Robert Pearsons**
> **WOODSTOCK**
> **Vermont**

The P, in Pearsons, is made with the same grand flourish Parrish used in his own signature. Three of the Pearson labels are known to exist. Others may exist with different names.

Art Portfolio. Published by Way and Williams, n.d., Chicago. Contains signed proofs of illustrations for *Mother Goose In Prose*. Rare.

Art Portfolio. Published by Edward Gross & Co. Six color prints from *Poems of Childhood*; **The Dinkey Bird, The Fly-Away Horse, The Little Peach, Seein' Things, Shuffle-Shoon and Amber Locks**, and **The Sugar Plum Tree**.

Art Portfolio. Published by The Century Company, n.d. "Six Color Plates of Italian Villas and Their Gardens From the Original Paintings by Maxfield Parrish." Prints 8″ by 5″ on mats which are 12½″ by 9¼″. **Boboli Gardens, In the Gardens of Isola Bella** (Lake Maggiore), **Villa Campi, Villa Cicogna, Villa D'Este**, and **Villa Medici**.

Blotter. Color. 4″ by 9¼″. Bears the Edison-Mazda design of two youths dressed in purple, chatting above a central panel on which the words, "Edison-Mazda Lamps," appear. Distributed by Scott-Buttner Electric. Other blotters, with different Parrish designs, are known to exist.

Book Matches. Color. 1¾″ by 1½″, closed. **The Broadmoor.** Advertising material used by The Broadmoor Hotel, Colorado Springs, Colorado.

Box, Crane Chocolates. Color. The top of this cardboard candy box lid measures 6½″ by 9½″. The illustration measures 4″ by 6″. A brown crane is shown vertically on the lid, with the wording, "Crane's Chocolates, Cleveland, New York." (It is believed that possibly **Cleopatra, The Garden of Allah** and **The Rubáiyát** may also have appeared on candy boxes, as these prints all bear the Crane copyright mark.)

Calendars, Desk Pad Style. Dodge Publishing Company. Color. 8″ by 5¾″. Calendars were available in "desk easel style, leather covers with blanketed design, Florentine brocade leather with full gold stamping, or punched to fit the desk easel style." The following ten choices of calendar covers by Parrish were offered: **The Brazen Boatman, Prince Codadad**, from *The Arabian Nights*; **Harvest, The Lantern Bearers, Summer**, from *The Golden Treasury*; **Cadmus, Circe's Palace, The Fountain of Pirene, Jason and the Talking Oak**, from *The Wonder Book*; and **The Land of Make-Believe.**

Calendar Prints. *International Studio* for February, 1908, advertises six calendar prints from *The Golden Age*. "Special ornamental design in two colors, in artistic box. $2.50." Size and titles unknown.

Calendar, Wall. See Edison-Mazda under "Individual Prints;" **Millpond**; and **The Spirit of Transportation.**

Calendar, Wall. Yankee Recipe Calendar, 1971. Month of December is illustrated with **Church at Norwich.** Published by Yankee, Inc., Dublin, New Hampshire, 03444.

Calendars, Wallet Edison-Mazda. Color. Celluloid wallet calendars bearing the Edison-Mazda calendar prints were published for advertising purposes.

Card, Postal. Color. 3½″ by 5½″. **The Broadmoor**. Advertising material used by The Broadmoor Hotel, Colorado Springs, Colorado.

Card, Postal. Color. 3½″ by 5½″. This design advertises a tearoom called, "The Tea Tray," and is a reproduction of the actual tearoom sign, which Parrish created. The card reads: "The Sign Board At The Tea House On The Cornish Road—New Hampshire." The picture shows a young couple sharing tea, at opposite ends of a table covered with a white cloth.

Card, Postal. Color. 3½″ by 5½″. This card bears the same inscription as the preceding entry, but the picture is of an older couple sharing tea, seated in carved white chairs at a green table, with a large silver tea service between them. This is a reproduction of the reverse side of the actual tearoom signboard.

Card, Postal. Color. 5½″ by 3½″. This scene was Parrish's contribution to the Vermont Association for Billboard Restriction, Springfield, Vermont. In the foreground is a blue lake with rocky slopes on either side. On the right a waterfall tumbles down the rocks beside a large tree. On the left, green water and more trees are seen. Lavender hills and a clear blue sky are in the background.

In the center of this idyllic scene is a billboard with a large ink blot on it. Words above and below the billboard state: "Buy Products Not Advertised On Our Roadsides." On the right end of the card, out of the picture, are the words: "The Billboard—A Blot On Nature—A Parasite On Public Improvements and A Menace To Safety."

Card, Postal. Color. 9″ by 6″. Copy of *Century Magazine*, Midsummer Holiday Number, August. Published by Nasty Jack Trading Co., Ltd., New York, 1971.

Card, Postal. Black and white photograph. 3½″ by 5½″. "Maxfield Parrish Residence, Plainfield, N.H." Published by Merrimack Post Card Co., 110 Merrimack St., Haverhill, Mass.

Card, Postal. Sepia. 3½″ by 5½″. "Hotel Knickerbocker—Main Bar—James B. Regan, Prop." Photograph of the bar with the mural, **Old King Cole** (St. Regis), on the wall behind it.

Card, Sample. Brown & Bigelow. Color. 6″ by 3¾″, and 6″ by 4½″. These cards were used as samples to show prospective customers. Titles are printed in black across the bottom of the prints. **Misty Morn, Morning Light, The Old Glen Mill, Peaceful Country, Quiet Solitude, Sheltering Oaks,** and **Under Summer Skies**, are known. Samples of other titles may exist.

Card, Trade. Elixir of Beef. There is reported to be a trade card for this product, with a Parrish design. Unverified.

Cards, Playing. Brown & Bigelow. Two different designs are known to have been used, with all the cards in a deck bearing the same design; **New Moon** and **Sheltering Oaks**.

Cards, Playing. Edison-Mazda. Ten different designs were printed, with all cards in a deck bearing the same design: **And Night is Fled, Contentment, Ecstasy, Egypt, Enchantment, The Lampseller of Bagdad, Reveries, The Spirit of Night, The Venetian Lamplighter,** and **The Waterfall.**

Cartons, for automobile light bulbs. Paper. These packaging cartons bear the Edison-Mazda design of two youths in purple, chatting above a central panel which bears the advertising. One of the youths toys with a light bulb.

Catalog, for Wanamaker's Store, Philadelphia, No. 42, Spring and Summer, 1897. Cover by Parrish. (See *Saturday Review*, March, 1964.)

Film, "Parrish Blue." Syracuse University, Educational Film Center, 1455 E. Colvin St., Syracuse, New York. Also available from the International Film Bureau Inc., Chicago. Film explores the life and work of Parrish. Narrated by Norman Rockwell, Donald Reichert and Maxfield Parrish, Jr. Twenty-five minutes, color. Available for rent or purchase.

Jewelry; pendant or lavalier. Approximately one inch in diameter, this bit of jewelry carries **The Dinkey Bird** design in colored enamels on what appears to be a nickel silver background. This may have been a "dime store" item. (Private collection. Rare.)

Jig-Saw Puzzles. Color. An advertisement for these puzzles appears in *Collier's Magazine*, July 3, 1909, p. 2. They were priced from 75¢ to $12.00. Titles included **Old King Cole** (not known which one), *The Arabian Nights* Series, and the following titles which identify illustrations from *The Knave of Hearts*: Forgiven (Violetta and the King); The Prince (**The Prince**); The Prince and the Princess (Violetta and the Knave); and Queen's Page (**The Page**). The last four puzzles measure 12″ by 9½″, and their boxes are marked, "Distributed Exclusively by The American News Company and Branches."

Lamp Shade. Circular shade is 6½″ in diameter at the top; 10″ in diameter at the bottom; and 7″ high. There is gold trim at the top and at the bottom. **Daybreak** is shown against a blue background. (Private collection.)

Letterhead. Hires Root Beer. Color. Letterhead measures 2¼″ by 6″, on stationary 11″ by 8½″. Design is of three elfin figures standing around a steaming kettle.

Poster, advertising. Fisk Tires. Color. 2′ by 4′. A knave rides through the sky seated on a tire. A view of an autumn landscape is seen through the tire.

Poster, advertising. Fisk Tires. Color. 2½′ by 1′, **Fit for a King**.

Poster, advertising. Hires Root Beer. 8½′ by 24′. Three elfin figures stand around a steaming kettle.

Poster, advertising. Hires Root Beer. Color. 2½′ by 1′. This advertisement came in two panels, which together made up the stated dimensions. A different elfin figure is on each panel.

Poster, advertising. Hires Root Beer. Color. 12″ by 25″. Three elfin figures stand around a steaming kettle.

Poster, advertising. Hires Root Beer. Color. This is a cardboard, stand-up figure taken from the full design of three elfin figures standing around a steaming kettle.

Poster, advertising. Hires Root Beer. Color. Another of the elfin figures as described in the preceding entry.

Poster, advertising. Jell-O. 2′ by 3′. Cardboard ends fold in so that the poster will stand alone, **The King and Queen**.

Sheet music. Cover in color for, "The Djer-Kiss Waltz," is the same as the Djer-Kiss Cosmetics advertisement of a girl in a swing, with bowers of roses over her head, and purple mountains in the distance.

Smoking tobacco package. 4-1/16″ by 2-3/4″ by 1″. Color. "Old King Cole Smoking Mixture," bears the center panel from **Old King Cole** (St. Regis). Reverse bears the company name, B. Wasserman Co., New York City. The only known example bears a tax stamp dated 1926. (Private collection. Rare.)

Tape measure. Color. Edison-Mazda design. This is a spring-type, reel-in measure, with a celluloid cover, which was distributed for advertising purposes.

Tie rack. This rack consists of a wooden plaque which is decorated with **Old King Cole** (St. Regis), presumably in color. At the base is fastened a brass rod to hold the ties; it hangs from two brass rings attached at the top. See advertisement, *Harper's Monthly*, May, 1928, 9th page.

Wallpaper Border. Color. 8″ by 42″. The Fisk Tire and Rubber Company created this item for advertising purposes. The design of **Mother Goose** riding on a Fisk Tire, is repeated on the border.

Yardstick. Reported to be a yardstick bearing an Edison-Mazda design. Unverified.

RELATED MATERIAL

Under "Related Material" will be found references to Cashmere-Bouquet, Royal Baking Powder and Colgate products advertisements which some collectors believe to have been done by Parrish. A doubt remains, however, and even persons who were close to the artist believe that some of these advertisements may have been done in the "Parrish style" by other illustrators. Because positive verification has not been made, they are not listed in the main body of the *Guide*, and are noted here by an asterisk.*

ARCHITECTURAL RECORD

1907. Oct. "The House of Mr. Maxfield Parrish," pp. 272-79. Six photographs of the interior and the exterior of the house.

ART DIGEST

1932. Apr. 1. "Portrait of A Gentleman," p. 11. Illustration of a modern metal sculpture by Maxfield Parrish, Jr.

THE CENTURY MAGAZINE

1906. May. Duncan, Frances. "The Gardens of Cornish," pp. 3-19. Two photographs of Maxfield Parrish's garden; three photographs of Stephen Parrish's garden.

COLLIER'S MAGAZINE

1907. Mar. 23. Collins, Sewell, "All The World Loves A Lover," a cartoon, p. unk., with apologies to Maxfield Parrish.

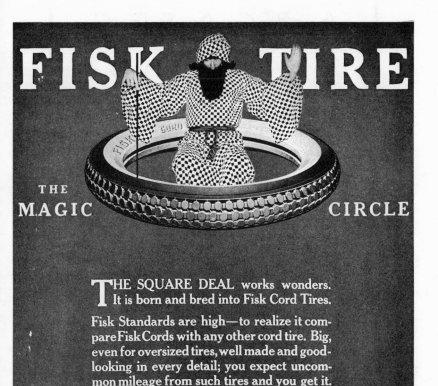

FISK TIRE

THE
MAGIC **CIRCLE**

THE SQUARE DEAL works wonders. It is born and bred into Fisk Cord Tires.

Fisk Standards are high—to realize it compare Fisk Cords with any other cord tire. Big, even for oversized tires, well made and good-looking in every detail; you expect uncommon mileage from such tires and you get it.

They are built to an ideal:

"To be the best concern in the world to work for and the squarest concern in existence to do business with."

Next time—BUY FISK from your dealer

Parrish's design for a Fisk Tire Company advertisement appearing in the *Century* magazine, December 1900

A B C D E F G
H I J K L M O P
Q R S T U V W
X Y Z.

a b c d e f g h i j
k l m n o p q r s t
u v w x y z.

Alphabet used for quick
lettering on plans, packages.

KNICKERBOCKER'S
HISTORY
OF NEW YORK
BY WASHINGTON IRVING

Two examples of Parrish lettering: an alphabet (above) and beneath it a title design for Knickerbocker's History. Both were printed in Frank Chouteau Brown's *Letters & Lettering*, 1902

1909. July 3. Advertisement, p. 2, for jig-saw puzzles with Parrish designs.

1910. Feb. 26. Editorial, p. 7, announces forthcoming Parrish frontispieces.

1936. Oct. 24. p. 28, portrait of the artist.

COUNTRY LIFE

1904. Mar. Royal Baking Powder advertisement, p. unk.*

1907. Oct. p. 670, photographs of two furniture hardware designs created by Parrish.

1908. Mar. Cover design of the gardens at Cornish, New Hampshire, of Stephen Parrish, the artist's father.

1920. Oct. "The Oaks, The Country Home of Maxfield Parrish at Cornish, New Hampshire," pp. 62-64. Photographic series only, by Mary Harrod Northend.

COUNTRY LIFE IN AMERICA

1913. July. Parrish, Maxfield. "The Garden of An Artist In New Hampshire. Designed, Planted and Photographed by Maxfield Parrish," pp. 42-43. Photographs only.

GOOD HOUSEKEEPING

1929. Oct. Boyle, Ruth. "A House That 'Just Grew'," p. 44. Four photographs; two of the interior, and two of the exterior, of Parrish's home.

HARPER'S BAZAR

1936. Dec. 26. Royal Baking Powder advertisement, p. unk.*

HARPER'S WEEKLY

1895. Dec. unk. Royal Baking Powder advertisement, p. unk.*

HOUSE BEAUTIFUL

1923. June. "The Garden of Maxfield Parrish in Cornish, New Hampshire," pp. 617-20. Photographic series only, by Clara E. Sipprell. Three full-page and one half-page views of Parrish's gardens.

LADIES' HOME JOURNAL

1901. Oct. Cashmere-Bouquet Toilet Soap advertisement,* on the back cover. Full-page Dutch boy in black, white and red, in the "Parrish style," but signed in the margin, "Serman."

———. **Nov.** Small black and white Colgate advertisement, p. 17.*

———. **Dec.** Small black and white Cashmere-Bouquet advertisement, p. 28.*

1902. June. "Glimpses In Some Beautiful Gardens," pp. 22-23. One of the photographs in this series was taken by Parrish.

1903. Apr. Colgate Violet Talc advertisement, back cover.*

1905. Feb. Colgate Antiseptic Powders advertisement, back cover.*

———. **Apr.** Colgate Violet Talc and Dental Powder advertisement, back cover.*

———. **June.** Colgate Violet Talc advertisement, p. 22.*

LIFE MAGAZINE

1950. Nov. 6. "The Connecticut River," pp. 123-32. Small photograph of the artist standing beside his fireplace.

LITTLE FOLKS MAGAZINE

1900. Jan. Colgate Violet Talc advertisement in sepia, back cover.*

1905. Jan. Colgate Violet Talc advertisement in green, back cover.*

———. Feb. Colgate Violet Talc advertisement in sepia, back cover.*

THE OUTLOOK

1899. Dec. Colgate advertisement, back cover.*

PARRISH, LYDIA.

(Wife.) *Slave Songs Of the Georgia Sea Islands.* New York: Farrar, Straus & Company, Inc., 1942. Hatboro, Pennsylvania: Folklore Associates, Inc., 1965.

SAYLOR, HENRY H.

Tinkering With Tools. New York: Popular Science Publishing Co., Inc., 1942, pp. 245-46. Two photographs of Parrish's machine shop.

SCRIBNER'S MAGAZINE

1899. Dec. Royal Baking Powder advertisement, back cover.*

1900. Jan. Cashmere-Bouquet Soap advertisement, p. unk.*

1903. Aug. Colgate Talc advertisement, p. unk.*

WOMAN'S HOME COMPANION

1901. Oct. Colgate Soap advertisement, p. unk.*

1915. June. Colgate Soap advertisement, p. unk.*

BIBLIOGRAPHY

BOOKS

American Art By American Artists. New York: P. F. Collier & Son, 1914.

Blashfield, Edwin H. *Mural Painting In America.* New York: Charles Scribner's Sons, 1913, p. 205.

Bolton, Theodore. *American Book Illustrators.* New York: R. R. Bowker, Co., 1938, pp. 118-19.

Bryan's Dictionary of Painters & Engravers. 5 vols. London: G. Bell & Sons, Ltd., 1926.

Bryant, Lorinda M. *American Pictures and Their Painters.* New York and London: John Lane, 1917, pp. 257-59.

Current Biography. New York: The H. H. Wilson Company, 1970, pp. 314-16. Portrait of the artist.

Dodd, Loring Holmes. *A Generation of Illustrators and Etchers.* Boston: Chapman & Grimes, Inc., 1960, pp. 91-95.

Encyclopedia of World Art. New York: McGraw-Hill Book Company, 1966. vol. 11, p. 790.

Gallatin, A. E. *Modern Art At Venice.* New York: J. M. Bowles, Publisher, 1910. pp. 41-45.

Jackman, Rilla Evelyn. *American Arts.* Chicago: Rand McNally & Company, 1928, pp. 34, 35, 276-79.

Kunitz, Stanley and Howard Haycraft, eds. *The Junior Book of Authors.* New York: H. H. Wilson Co., 1951, pp. 235-36. (The 1934 edition contains a portrait of Parrish.)

Mather, Frank Jewett, Jr., Charles Rufus Morey and William James Henderson, eds. *The Pageant of America*, vol. 12, p. 302.

Meyers, Bernard S., ed. *McGraw-Hill Dictionary of Art.* New York: McGraw-Hill Book Co., 1969, vol. 4, p. 308.

Miller (Mahoney), Bertha E., Louise Latimer and Beulah Folms-
bee, compilers. *Illustrators of Children's Books 1744-1945*.
Boston: The Horn Book Inc., 1947. References to Parrish as a
pupil of Howard Pyle, pp. 115, 121, 184, 229; biography, p. 344.
──────and Elinor Whitney, compilers. *Contemporary Illustrators of
Children's Books*. Women's Educational and Industrial Union,
1930. Biography; quotations from Hubert von Herkomer.

Neuhaus, E. *The History and Ideals of American Art*. Stanford
University, California: Stanford University Press, 1931, pp.
366, 386-87.

Norell, Irene P. *Maxfield Parrish, New Hampshire Artist, 1870-
1966. A Contribution Toward A Bibliography*. San Jose,
California: Irene P. Norell, 1971.

Petaja, Emil. *And Flights of Angels*. San Francisco: The Boka-
nalia Memorial Foundation, 1968. Bibliographical material on
the artist Hannes Bok, which deals in part with his admiration
for, and study under, Parrish. Photograph of Parrish; photo-
graph of Bok with a Parrish original.

Price, Charles Matlack. *Posters: A Critical Study of the Develop-
ment . . .* New York: George W. Bricka, 1913, pp. 179, 181,
183, 351-53, 355, 357.

Reed, Walter, ed. *The Illustrator In America 1900-1960's*. New
York: Reinhold Publishing Corporation, 1966, p. 64.

Weitenkampf, Frank. *The Illustrated Book*. New York: Cambridge
Harvard University Press, 1938, p. 219.

PERIODICALS

Adams, Adeline, "The Art of Maxfield Parrish," *The American
Magazine of Art*, January, 1918, pp. 84-101.

Allen, Charles D. "The Appeal of the Bookplate—Antiquarian
and Artistic," *The Century Magazine*, Dec., 1901, pp. 240-46.

Alloway, Lawrence. "The Return of Maxfield Parrish," *Show—The
Magazine of the Arts*, May, 1964, pp. 62-67.

"American Art Comes of Age," *Life*, Oct. 21, 1938, pp. 27-30.

Ames, Richard. "Maxfield Parrish for Fine Technique," *Santa
Barbara News-Press*, September 17, 1967, p. C-10.

"An Illustrated Washington Irving Miscellany," *American Heri-
tage*, December, 1961, pp. 41-55.

The Art Digest, July, 1931, p. 16. Editorial report concerns

Parrish's decision to cease painting "girl-on-rocks" themes, and to concentrate on painting nature.

"Art Features of the New Books," *Brush and Pencil*, January, 1898, pp. 126-28.

"Art In Philadelphia," *The Nation*, February 22, 1912, p. 196.

Art News, February 22, 1936, p. 9 v. Notice of exhibition of Parrish work at the Ferargil Galleries.

————. January 15, 1942, p. 15. Portrait of Parrish by Kenyon Cox.

Ayers, Priscilla. "Profile Personalities—Consummate Artist," *New Hampshire Profiles*, December, 1955, p. 65.

Belisle, Pat. "Parrish Illustrations," *Eastern Antiquity*, December, 1970, p. 18.

Betz, Les. "The Western Art of Maxfield Parrish," *Real West Magazine*, August, 1969, pp. 40-43.

"Bicycle Posters," *The Critic*, April 4, 1896, p. 243.

Breitenbach, Edgar. "The Poster Craze," *American Heritage*, February, 1962, pp. 26-31.

Brinton, Christian. "Master of Make-Believe," *The Century Magazine*, July, 1912, pp. 340-52.

Brinton, Selwyn. "Modern Mural Decoration In America," *International Studio*, January, 1911, pp. 175-90.

Butterfield, Roger. "The Best Years of A Long, Full Life," *Life Magazine*, January 24, 1969, p. 55.

"Calendars," *Life Magazine*, January 1, 1945, pp. 41-46.

Canaday, John. "Maxfield Parrish, Target Artist," *The New York Times*, June 7, 1964, p. X-21.

Carrington, James B. "The Work of Maxfield Parrish," *The Book Buyer*, April, 1898, pp. 220-24.

Cheney, Sheldon. "Personality In Book-Plates," *Dress & Vanity Fair*, October, 1913, p. 171. Mentions the "Parrish style."

"The Connecticut River," *Life Magazine*, November 6, 1950, pp. 123-32. Portrait of the artist.

"Domesticated Colors," *Time*, February 17, 1936, pp. 34-35. Mention of exhibition of Parrish work at the Ferargil Galleries. Portrait of the artist.

Duncan, Frances. "Maxfield Parrish's Home and How He Built It—Art In Craftsmanship," *Country Calendar*, September, 1905, pp. 435-37.

Gilett, G. Elizabeth. "His Skies Are Blue—Maxfield Parrish At Ninety-Three," *The Saturday Review*, March, 1964, pp. 129-30.

"A Girls' Dining Room of Maxfield Parrish Paintings," *Ladies' Home Journal*, November, 1911, p. 1.

Glaenzer, Richard Butler. "To Maxfield Parrish," *Century Magazine*, February, 1907, p. 80. A poem.

Glueck, Grace. "A Taste of Parrish," *American Heritage*, December, 1970, pp. 16-27.

"Grand-Pop; At Manhattan's Gallery of Modern Art," *Time*, June 12, 1964, p. 76. Portrait of the artist.

Henderson, Helen. "The Artistic Home of the Mask and Wig Club," *House and Garden*, April, 1904, pp. 168-74.

Hoeber, Arthur. "A Century of American Illustration," *The Bookman*, February, 1899, pp. 540-48.

―――. "American Mural Painters," *The Mentor*, September, 1914, pp. 1-11.

Holman, George. "Maxfield Parrish Looks At Vermont," *Vermont Life*, Summer, 1952, pp. 12-15. Photographs of the artist, his home and his machine shop.

"The House of Mr. Maxfield Parrish," *Architectural Record*, October, 1907, pp. 272-79.

International Studio, April, 1909, pp. 166-67. Sixth Annual Exhibition of the Philadelphia Water Color Club, at the Pennsylvania Academy of Fine Arts, announces Parrish as winner of the Beck Prize for **Landing of the Brazen Boatman**, from *The Arabian Nights*.

Irvine, H. J. "Professor von Herkomer on Maxfield Parrish's Book Illustrations," *International Studio*, July, 1906, pp. 35-42.

Kent, Norman. "In the Azure Blue," *American Artist*, June, 1966, p. 71. Editorial obituary.

Knaufft, Ernst. "Art In the Holiday Books," *The American Monthly Review of Reviews*, December, 1900, p. 750.

Koethe, John. "Boston Is Here, Now," *Art News*, September, 1969, p. 31.

"Leading American Illustrators," *Independent,* Nov. 21, 1907, p. 1201.

Litevich, John. "Maxfield Parrish—New Hampshire Man of American Tradition," *New Hampshire Profiles*, Dec., 1966, pp. 38-39. Portrait of the artist.

Ludwig, Coy. "From Parlor Print to Museum: The Art of Maxfield Parrish," *The Art Journal*, Winter, 1965-66, pp. 143-46.

Martin, C. S. "Knickerbocker Days," *Cosmopolitan*, Jan., 1901, pp. 219-28.

"Maxfield Parrish As A Mechanic," *The Literary Digest*, May 12, 1923, pp. 40-44. Portrait of the artist.

"Maxfield Parrish, Painter and Illustrator Dies At 95," *The New York Times*, March 31, 1966, p. 39. Portrait of the artist.

Merrill, Charles. "Dreams Come True In His Workshop," *The Mentor*, June, 1927, pp. 21-22.

Moffat, William. "Maxfield Parrish and His Work," *The Outlook*, December, 1904, pp. 838-41.

Morris, Harrison S. "Philadelphia's Contribution to American Art," *The Century Magazine*, March, 1905, pp. 714-33.

North, Ernest Dressel. "A Group of Young Illustrators," *The Outlook*, December 2, 1899, p. 166.

"A Note On Some New Paintings By Maxfield Parrish," *International Studio*, August, 1912, pp. 25-26.

"Offensive Billboards," *The Nation*, December 6, 1917, p. 629.

Parrish, Maxfield. "Inspiration In the Nineties," *The Haverford Review*, Autumn, 1942, pp. 14-16.

"Parrish Still Popular," *The Art Digest*, September, 1948, p. 21.

"Parrish's Magical Blues," *The Literary Digest*, February 22, 1936, pp. 24-25.

"Philadelphia. The Republican Party Has A Homecoming," *Life Magazine*, June 24, 1940, pp. 62-73.

Pollard, Percival. "American Poster Lore," *The Poster*, March, 1899, pp. 123-27.

"The Poster of Today," *The Art Interchange*, June, 1896, pp. 138-39.

"Recent Works By Maxfield Parrish," *The New York Herald Tribune*, February 16, 1936. Mentions the following works: **In the Mountains; Elm, Autumn** (single title); **Sugar Hill, Late Afternoon** (single title); and a sketch for a decorative panel in the music room of Mr. Irenée du Pont.

Saint Gaudens, Homer. "Maxfield Parrish," *The Critic*, June, 1905, pp. 512-21.

"Speaking of Pictures," *Life Magazine*, December 30, 1940, p. 137. Mention of Parrish's **Village Brook** as the third place best-seller for Brown & Bigelow.

"The Story of the Arabian Nights," *The Mentor*, March, 1922, pp. 13-28.

Sweeney, Marian S. "Maxfield Parrish Prints: Bring Enchantment to Californian," *The Collectors News*, February, 1971, pp. 1, 4.

Taylor, Frank J. "From Saloon To Salon," *The Saturday Evening Post*, June 20, 1936, p. 23.

Taylor, Robert. "Maxfield Parrish Is In," *The Boston Herald*, May 24, 1966, Section A-39.

Thorndike, Alan. "New England Sky Is Parrish Blue," *The Connecticut Valley Reporter*, January 12, 1972, pp. 1, 7.

Time, April 8, 1966, p. 102. Obituary.

"We Know Him Well," *Newsweek*, June 6, 1960, p. 110.

Wisehart, M. K. "Maxfield Parrish Tells Why the First Forty Years Are the Hardest," *American Magazine*, May, 1930, pp. 28-31. Portrait of the artist; photographs of his home and his machine shop.

PAMPHLETS AND CATALOGS

The Artist Reacts: 6 Film Series. Syracuse, New York. Syracuse University, p. 2-3.

The Broadmoor Story. Colorado Springs, Colorado, 1968, p. 12.

Exhibition of Paintings by Maxfield Parrish During the Month of July, 1950: Saint-Gaudens Memorial, Cornish, New Hampshire. Cornish, New Hampshire, 1950. Saint-Gaudens Memorial. No reproductions. Lists the fifty-four works shown at the exhibition.

Maxfield Parrish. Boston, 1968. The Vose Galleries.

Maxfield Parrish: A Retrospect. Springfield, Massachusetts, 1966. The George Walter Vincent Smith Art Museum.

Maxfield Parrish—May 4-26, 1964. Bennington, Vermont. Bennington College.

Maxfield Parrish, Painter and Illustrator. Dover, New Jersey. Reliance Picture Frame Co., Inc.

The Return of Maxfield Parrish. 1870-1966. Boston, 1967. The Vose Galleries.

Tiffany, Louis Comfort. *The Dream Garden.* Philadelphia, 1915. The Curtis Publishing Company.

FILM

Parrish Blue. Syracuse, New York. Syracuse University.

LATE LISTINGS

BOOKS

Discovering Antiques. vol. II. New York: Greystone Press, n.d., p. 211. Black and white illustration, *Scribner's* Fiction Number, August.

Maxfield Parrish. Coy Ludwig. New York: Watson-Guptill Publications, 1973. A comprehensive biography of Parrish and his work. Large 9 by 12 format with 64 color plates and 102 black and white illustrations; bibliography; index.

Maxfield Parrish: The Early Years, 1893-1930. Paul W. Skeeters. Los Angeles: Nash Publishing Corp., 1973. Commentary on Parrish and his earlier art. A large 10 by 14 format with 230 illustrations of which 170 are in color.

PERIODICALS

Harper's Young People. 1895, Easter. Cover, description unk.

Outing Magazine. 1907, May. Reported to be cover in color. Unverified.

RELATED MATERIAL

New York Times Book Review. 1973, Dec. 2. Review of the Ludwig and Skeeters books on Parrish (see above), illustrated.

Publishers Weekly, 1973, Aug. 23. Advertisements for the Ludwig and Skeeters books on Parrish (see above). Book covers are illustrated.

Ski Magazine. 1973, Jan. Article on Maxfield Parrish's house in Cornish, N.H., now a gourmet restaurant. Photograph of the house.

INDEX